LOCOMOTIVES OF THE EASTERN UNITED STATES

Christopher Esposito

AMBERLEY

Author Bio

Christopher Esposito has been fascinated with trains ever since his father gave him a Lionel electric trainset at the impressionable age of two. Through the years this interest grew, and eventually led to a passion for photography as well. Christopher loves being able to explore all different parts of the country while out photographing railroads. When not chasing trains up and down the east coast, Christopher resides in Charlotte, NC with his wife Amy and their four young children.

Front cover: Norfolk Southern EMD SD80MAC No. 7205 (ex-CR No. 4109) leads 35A westbound through Duncannon, PA on the eastern end of the Pittsburgh Line. Taken on 22 June 2018.

First published 2018

Amberley Publishing
The Hill, Stroud
Gloucestershire, GL5 4EP

www.amberley-books.com

Copyright © Christopher Esposito, 2018

The right of Christopher Esposito to be identified as the Author of this work has been asserted in accordance with the Copyrights, Designs and Patents Act 1988.

ISBN 978 1 4456 8302 7 (print)
ISBN 978 1 4456 8303 4 (ebook)

British Library Cataloguing in Publication Data.
A catalogue record for this book is available from the British Library.

Origination by Amberley Publishing.
Printed in the UK.

Introduction

The Eastern United States offers some of the best scenery in the country and some of the most demanding. Railroads in this region must traverse numerous mountain grades, making each trip a challenge to the crew and the equipment. Since the early days of railroading, the railways have used the latest steam and diesel locomotives to move freight and passengers over this terrain. While there may be less variety in terms of motive power and railroads today, the mission is still the same – move an incredible amount of tonnage across rugged terrain as quickly and efficiently as possible, and the modern motive power available from EMD and GE is up to the task. The main engines used today for freight services are the SD70ACe from EMD (now owned by Caterpillar) and the GEVO model from GE. These modern locomotives, with up to 4,300 hp per unit, are used to haul unit coal, priority intermodal and general freight across the nation. Most of these newer units now use more efficient AC traction technology instead of the traditional DC. Older units, such as the SD40-2, GP38-2 and Dash-9, can still be found earning their keep for their respective owners as well. Due to years of mergers and consolidation, the Eastern US is dominated by two Class I railroads – Norfolk Southern and CSX – although power from the Western and Canadian railroads will appear often as well. Amtrak's main choice of passenger motive power is the GE-built P42 Genesis diesel.

Focusing primarily on the lines of the Norfolk Southern Railroad, this book explores some of the well-known lines and locations in the eastern half of the US. The famed Norfolk Southern Pittsburgh Line, running from Harrisburg, PA to just outside of Pittsburgh, PA, is the primary route for NS trains from the east coast markets to western connections in Chicago. High-speed intermodals, manifest freights, coal and even a manned helper district all contribute to the action and draw for fans of the former Pennsylvania Railroad Main Line. The 'eighth wonder of the world', Horseshoe Curve, is located along this line, in Altoona, PA. Not as glamorous as the ex-PRR main, but still important, are the former Reading Lines, originating out of Pennsylvania's capital, Harrisburg. These lines act as a bridge to the northern New Jersey/NYC metropolitan area to the east and connections in Maryland and Virginia to the south. Quaint farmlands and feed mills dot the landscape along these areas of the Keystone state.

Former Norfolk & Western lines make up the districts emanating out of Roanoke, VA. The Christiansburg, Whitethorne and Pulaski districts head west out of the 'star city' and are a vital part of the NS system. Coal bound for export, intermodals and general freight make up much of the traffic on these lines. Less traveled, but still significant lines connecting in Roanoke are the ex-Virginian Alta Vista district and the old N&W Roanoke District, which travels through the scenic Shenandoah Valley region.

We also look deep in the heart of West Virginia coal country at the Norfolk Southern Pocahontas District. Steeped in folklore to fans of the N&W, the 'Pokey' continues to provide a steady output of coal for domestic consumption and foreign export. In recent years, NS has been using it as a through route for intermodal traffic to Chicago as the coal loadings have tapered off somewhat.

Former Southern Railway and Seaboard lines make a showing at locations around North and South Carolina and Georgia.

In New Jersey, NS and CSX run over the jointly owned Lehigh Line as they compete to bring their freight and intermodal cargo to the New York and Philadelphia markets. New Jersey is also home to Amtrak's former Pennsylvania Railroad high-speed Northeast Corridor. Stretching from Boston, MA to Washington DC, it's one of the busiest passenger main lines in the world. The NEC is also used by commuter railroads New Jersey Transit, Metro North, SEPTA, MBTA and MARC along the way. NS and CSX provide most local freight services along the corridor. NJ Transit provides local commuter services to New York City on a web of former Jersey Central & Erie Lackawanna lines. In addition to the Class I action of NS and CSX, there are numerous shortline operators that serve local regions and industries. Most of these lines usually roster an interesting mix of older generation motive power and interchange with NS or CSX.

Join railroad photographer Christopher Esposito for a pictorial look at these great modern machines as they navigate through some of the best scenery and iconic locations of railroading in the Eastern United States.

Virginia

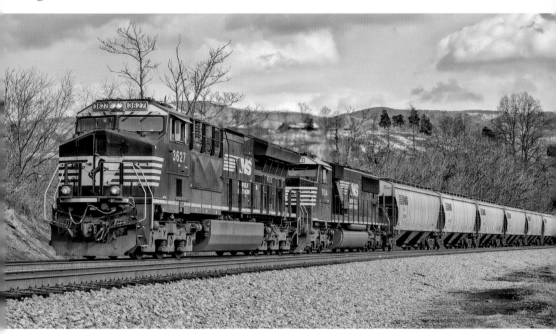

Norfolk Southern GE ET44AC No. 3627 leads an EMD SD60E as they bring westbound No. 51Z through Shawsville, VA on the Christiansburg District. Taken on 13 March 2018.

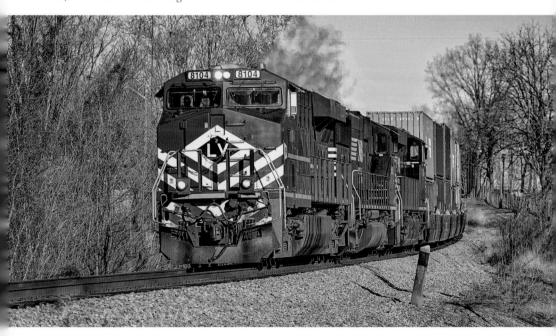

Bound for Louisville, KY, Norfolk Southern GE ES44AC No. 8104 hustles intermodal No. 22A through Abingdon, VA on the Pulaski District. NS No. 8104 is painted in the heritage scheme of Pennsylvania coal hauler The Lehigh Valley Railroad. Taken on 28 December 2016.

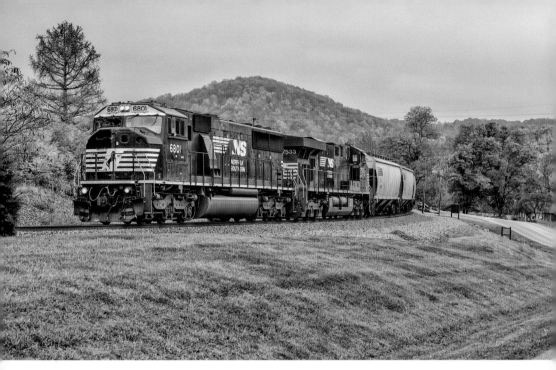

Originally built as Conrail No. 5565, NS EMD SD60M No. 6801 is seen hauling a unit grain train through Riverside on the ex-Virginian main line in Wabun, VA. Taken on 5 November 2017.

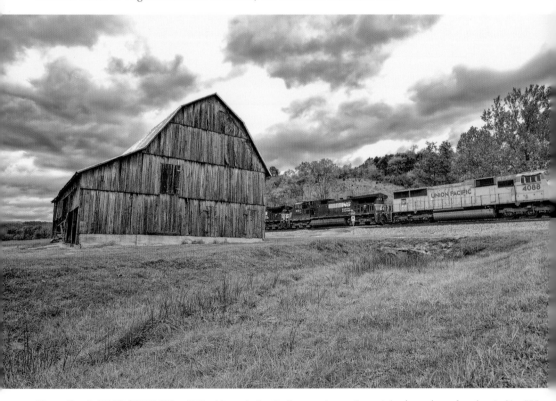

Union Pacific EMD SD70M No. 4088 adds a splash of color on a dreary day as it leads eastbound coal train No. 822 through Kumis, VA on the NS Whitethorne District. Taken on 28 October 2017.

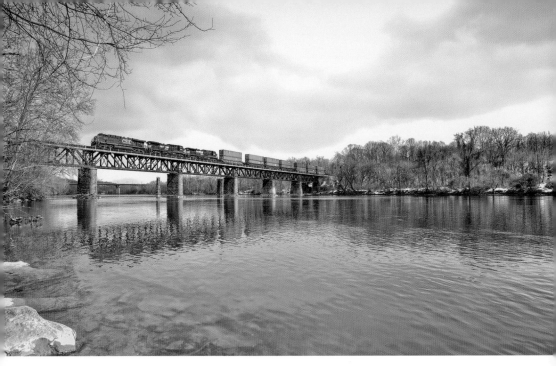

CSX GE ES44DC No. 5273 is on the point of NS No. 201 as it crosses the New River in Radford, VA on the Pulaski District. Taken on 13 March 2018.

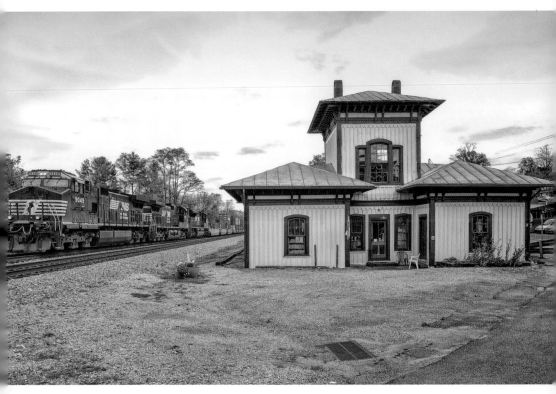

Norfolk Southern GE D9-44CW No. 9049 is in charge of westbound No. 29G as it heads past the former N&W depot in Christiansburg, VA. Taken on 1 November 2017.

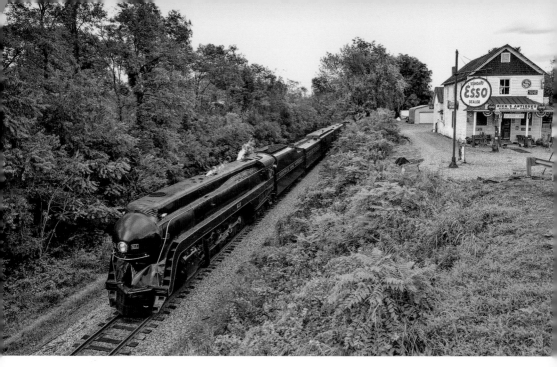

N&W J class No. 611 passes through Forest, VA on the Blue Ridge District as she heads home to Roanoke. Taken on 26 September 2018.

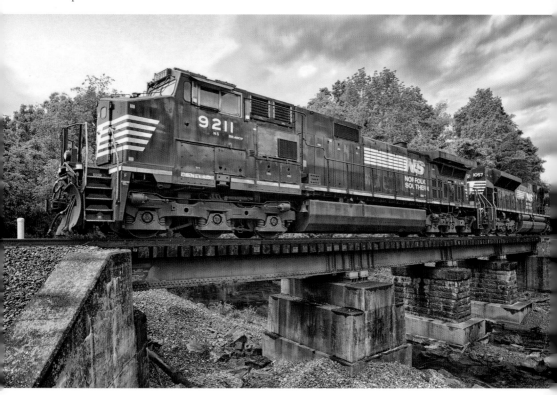

Norfolk Southern GE Dash-9 No. 9211 is seen leading local No. V37 over Peak Creek at Pulaski, VA on the Pulaski District. Taken on 8 June 2017.

The Shenandoah Valley region in Virginia has some of the best scenery in the east. The sound of three hardworking diesels reverberates off the mountains as they lead No. 202 through a location aptly known on the railroad as 'Solitude', bound for Rutherford, PA. Taken in Arcadia, VA on 15 February 2018.

As a result of their recent rebuild programs, the Norfolk Southern roster features EMD and GE variants not found on other roads. One such example is the EMD SD60E, which is seen here passing Big Spring Mill as it leads manifest No. 188 through Elliston, VA. Taken on 27 July 2017.

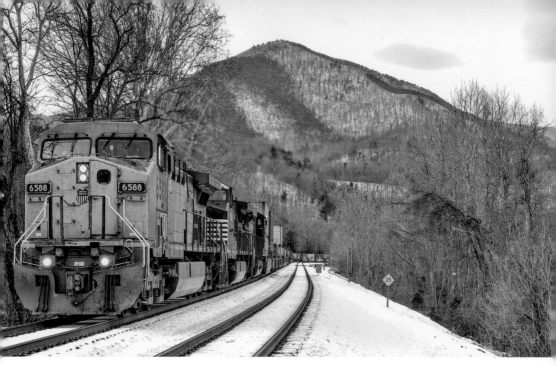

Union Pacific GE AC44CW No. 6588 leads eastbound intermodal No. 234 through Wabun, VA on the ex-N&W main line as a light dusting of snow covers the ground. Taken on 13 March 2018.

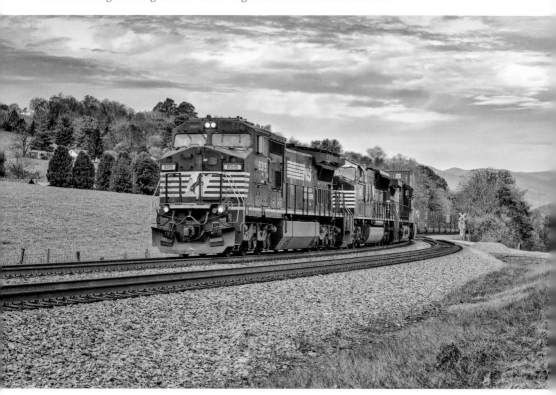

GE Dash 8-40CW No. 8315 was originally built in 1990 as Conrail No. 6053. Seventeen years later, it's seen working for new owner Norfolk Southern as it leads intermodal No. 201 through Shawsville, VA. Taken on 1 November 2017.

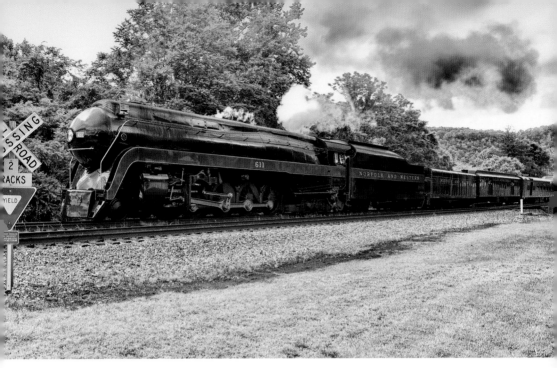

Norfolk & Western J Class No. 611 is back on home rails as she leads an excursion westbound out of Roanoke, VA. Taken in Elliston, VA on 27 May 2017.

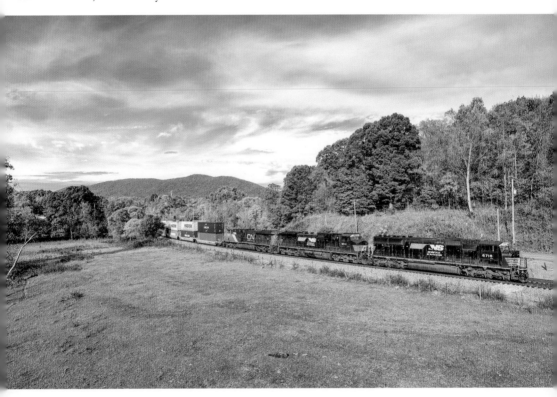

Norfolk Southern EMD SD60I No. 6718 (ex-CR No. 5578) leads No. 236 under the Blue Ridge Parkway as it heads towards Lynchburg on the Blue Ridge District. Taken in Bonsack, VA on 28 October 2017.

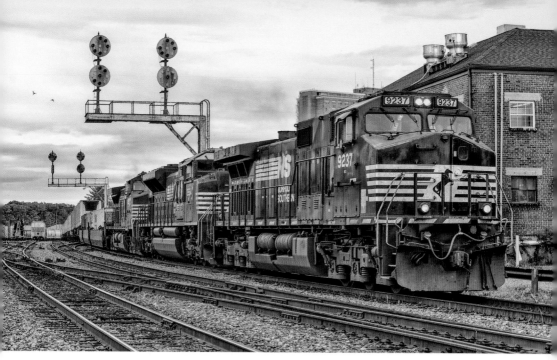

Norfolk Southern GE D9-44CW No. 9237 ducks under the now replaced N&W signal bridge with westbound No. 201 at Radford, VA. Taken on 29 July 2017.

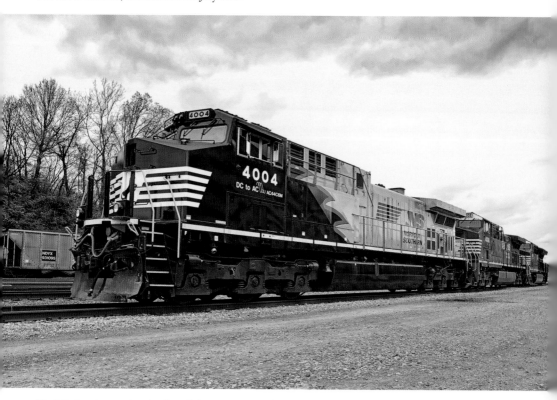

Norfolk Southern painted a few of their recent GE AC44C6M diesels in special schemes. AC44C6M No. 4004 (rebuilt from NS D9-40C No. 8866) is seen resting in Roanoke's South Yard. Taken on 8 April 2017.

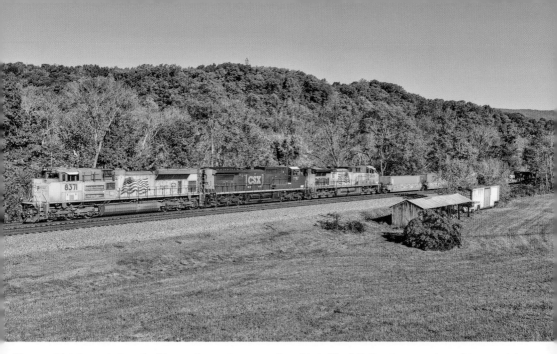

You wouldn't know it from looking at the motive power, but this is Norfolk Southern westbound intermodal No. 22A. Union Pacific EMD SD70ACe No. 8371 leads a CSX Dash-8 and a UP AC44CWCTE as they move through Wabun, VA. Taken on 27 October 2017.

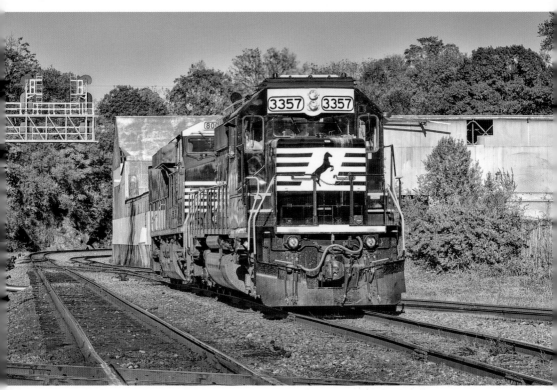

Former Conrail EMD SD40-2 No. 6409, built in 1977, is seen leading a power move through JK interlocking in Roanoke, VA. Taken on 27 October 2017.

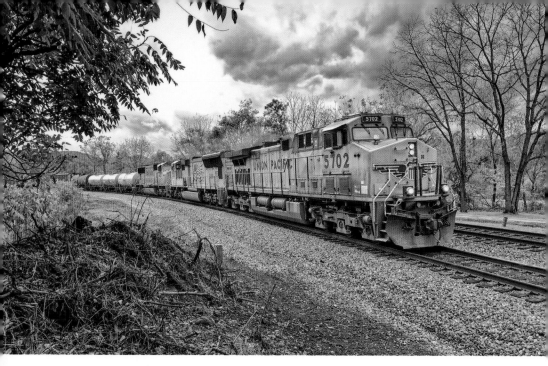

With storm clouds on the horizon, Union Pacific GE AC44CWCTE No. 5702 leads NS No. 194 through Wabun, VA on the Christiansburg District. Taken on 28 October 2017.

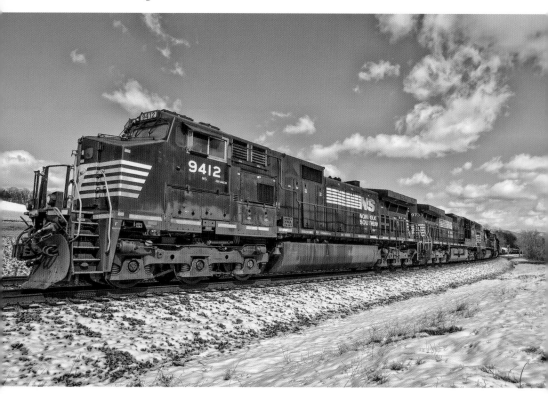

With GE Dash-9 No. 9412 leading, Norfolk Southern Roanoke, VA–Elkhart, IN manifest No. 11G heads through snow-covered Shawsville, VA. Taken on 13 March 2018.

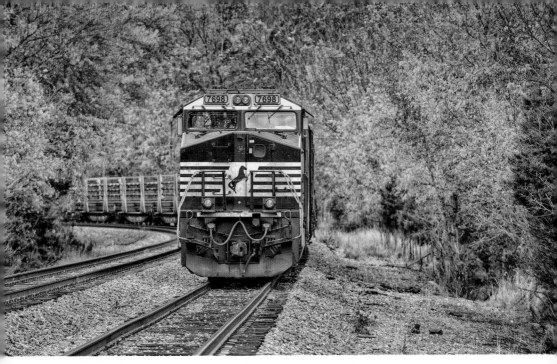

Norfolk Southern GE ES44DC No. 7698 is seen passing through Arcadia, VA with a MoW train on the Roanoke District. Taken on 29 October 2017.

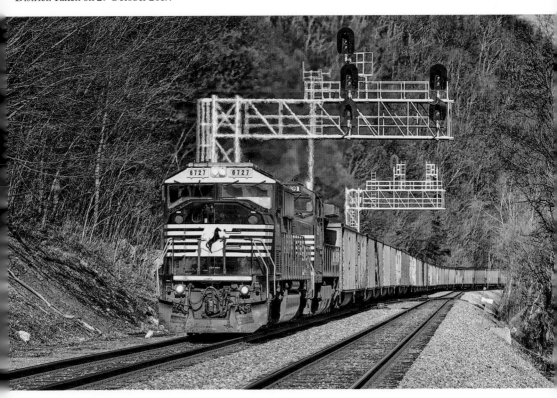

Former Conrail EMD SD60I No. 5593 leads an eastbound coal drag under the signals at Robinson, just west of Narrows, VA, on the Christiansburg District. Taken on 28 December 2016.

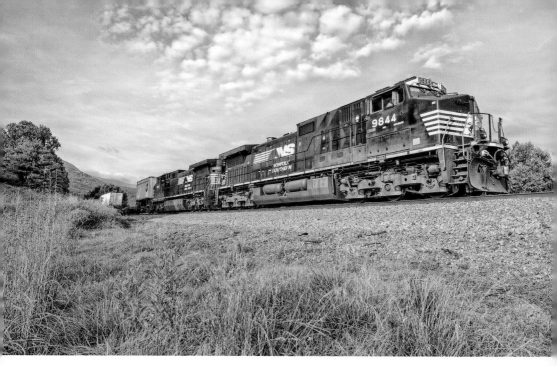

In the early morning, Norfolk Southern GE Dash-9 No. 9844 leads eastbound No. 234 through Wabun, VA on the Christiansburg District. Taken on 27 July 2017.

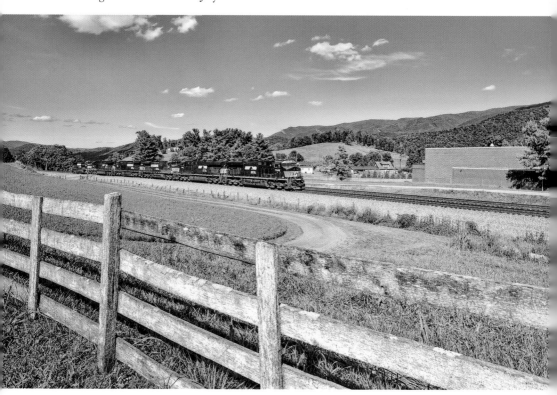

Norfolk Southern GE ES44DC No. 7589 leads five other units past the well-known 'John's Farm' at Shawsville, VA on a westbound power move. Taken on 5 August 2017.

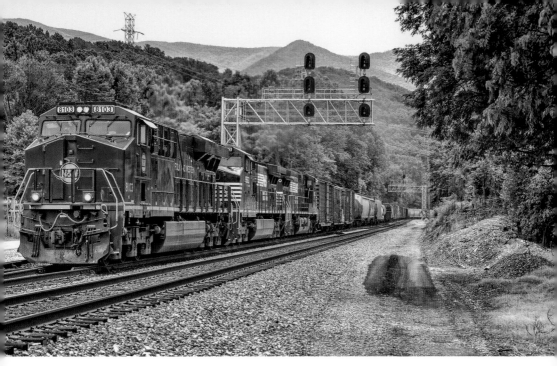

The Norfolk & Western heritage (GE-built ES44AC) unit is on home rails as it leads Pennsylvania-bound 16T at Singer in Wabun, VA on the Christiansburg District. Taken on 18 July 2018.

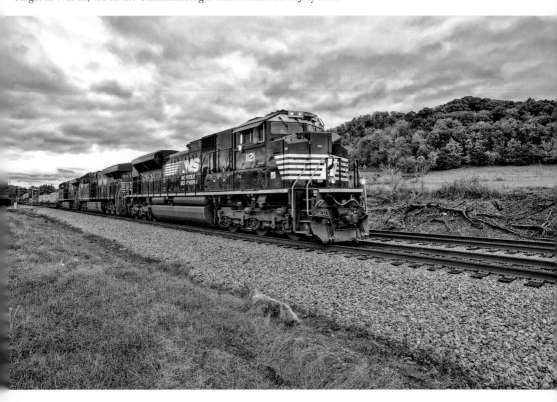

EMD SD70ACe No. 1121 hustles through Elliston, VA with a late-running Chicago-bound No. 217. Taken on 29 October 2017.

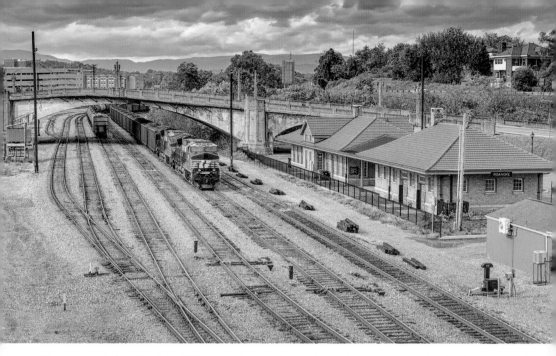

The restored former Virginian Railway station stands guard over the numerous coal trains that come and go through South Yard in Roanoke, VA. Recently built GE ET44AC No. 3674 prepares to depart to the eastern ports of Virginia with a trainload of export coal. Taken on 28 October 2017.

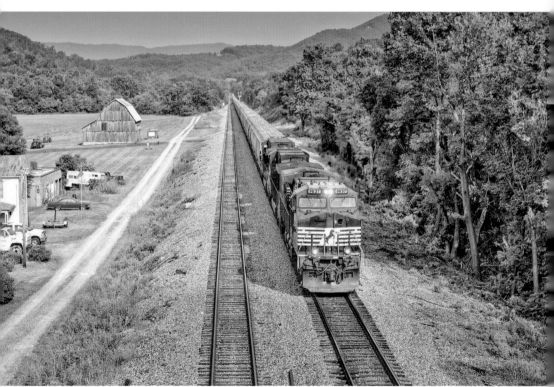

NS Dash-9 No. 9037 is seen leading Carolina-bound grain train No. 52Z through Kumis, VA on the Whitethorne District. Taken on 27 July 2017.

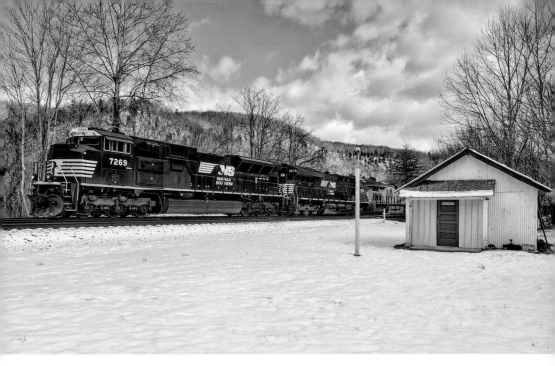

One of Norfolk Southern's unique rebuilt EMD SD70ACU units is seen leading No. 22A through a snowy Elliston, VA on the Christiansburg District. Taken on 13 March 2018.

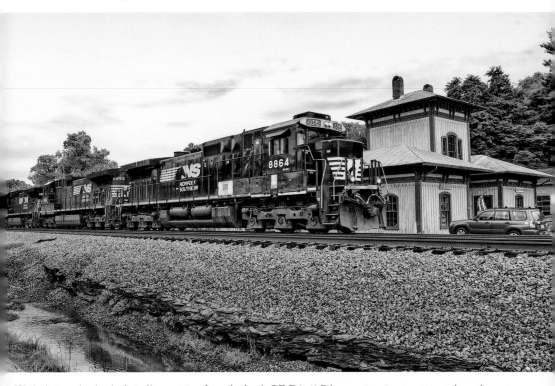

With their ranks slowly dwindling, a trio of standard-cab GE D9-40C locomotives is a treat to catch on the main line. They are seen here on westbound power move No. V51 as they move through Christiansburg, VA. Taken on 27 July 2017.

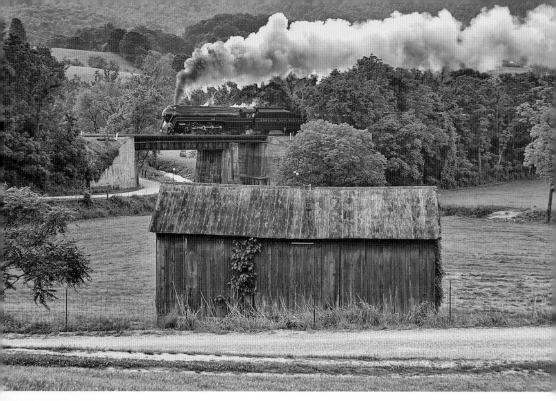

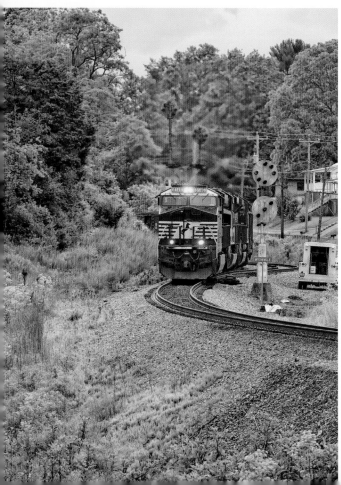

Above: Norfolk & Western No. 611 breaks the silence of the early morning as she passes a small farm just outside of Webster, VA. This is a scene that has not changed all that much since she regularly ran these same rails over sixty years ago. Taken on 28 May 2017.

Left: NS GE ES44AC No. 8146 leads a late-running westbound No. 165 past the now replaced N&W signals as it heads through Wytheville, VA on the Pulaski District. Taken on 8 June 2017.

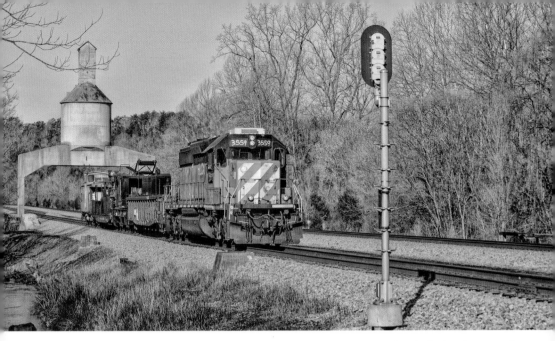

Older EMD diesels refuse to die and usually find second or third careers with other railroads. Such is the case with NS SD40-2 No. 3559. Originally built for the Burlington Northern in 1980, the unit found a new life working in lease service for HLCX as their No. 8139. NS purchased the unit in 2013. It is seen passing through Vicker, VA with an eastbound work train. The ex-N&W coal tower looms in the background. Taken on 21 March 2014.

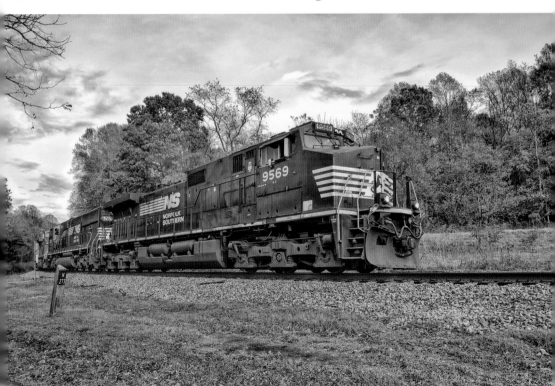

Norfolk Southern GE Dash-9 No. 9569 leads westbound No. 189 past milepost N273 near Wabun, VA on the Christiansburg District. Taken on 1 November 2017.

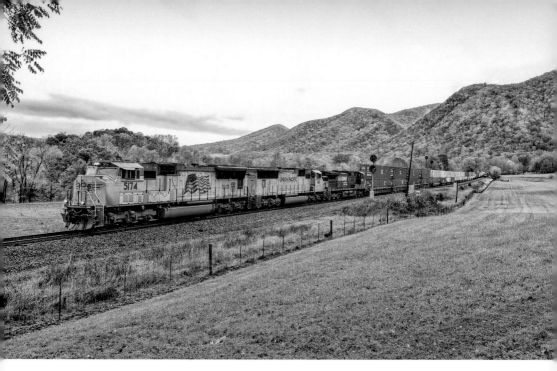

With Fall foliage still not showing much on the mountains, Union Pacific EMD SD70M No. 5714 leads No. 201 through Arcadia, VA. Taken on 29 October 2017.

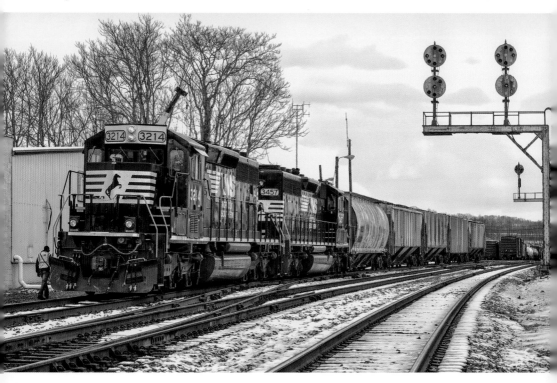

In recent years, Norfolk Southern has rebuilt many of the ex-Southern and N&W EMD SD40-2 units with a low, short hood using the NS-designed Admiral Cab. Former Southern No. 3214 is seen at Radford, VA on the Pulaski District with local No. V39. Taken on 13 March 2018.

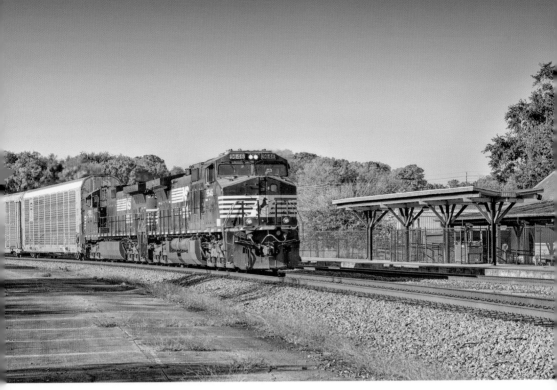

Norfolk Southern GE Dash-9 No. 9646 leads New Jersey-bound No. 290 past the former Southern depot in the Danville District's namesake city. Taken on 23 September 2017.

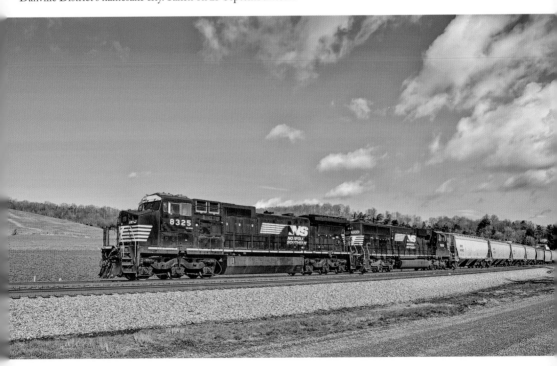

Norfolk Southern Dash 8-40CW No. 8325 (ex-CR No. 6069) leads a westbound grain train through the open vistas of Shawsville, VA. Taken on 18 March 2017.

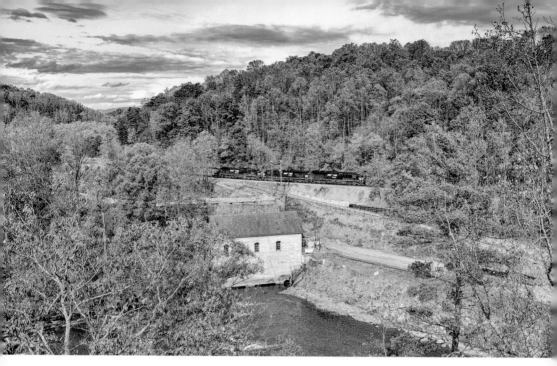

A trio of NS GE motors hustle export coal train No. 820 through Vinton, VA on the old Virginian main line in a view taken from the Blue Ridge Parkway. Taken on 28 October 2017.

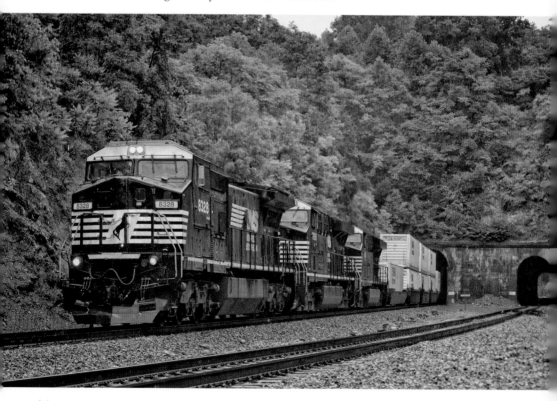

A heavy summer rain hits the ground as ex-Conrail Dash-8 No. 6073 heads westbound out of Montgomery Tunnel with No. 201. Taken on 1 August 2014.

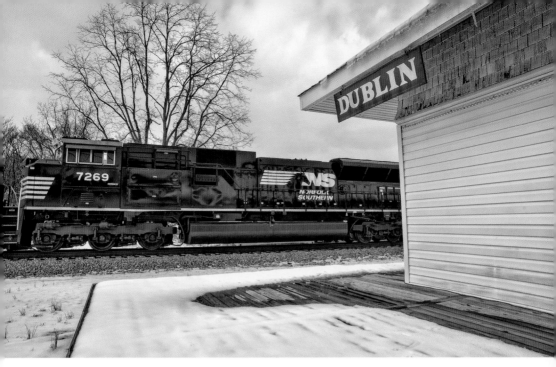

One of Norfolk Southern's rebuilt EMD SD70ACUs passes the former N&W depot in Dublin, VA with No. 22A on the Pulaski District. Taken on 13 March 2018.

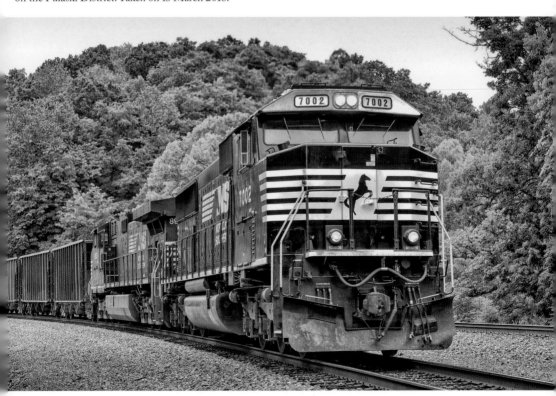

Norfolk Southern rebuilt EMD SD60E No. 7002 (ex-NS SD60 No. 6588) leads eastbound No. 68R through Shawsville, VA on the Christiansburg District. Taken on 27 July 2017.

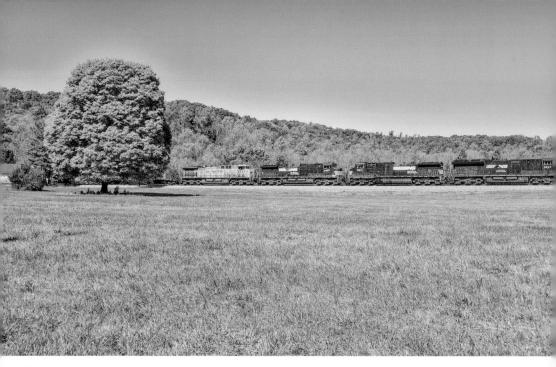

Norfolk Southern GE ET44AC No. 3627 leads three older generation GE motors as it heads No. 236 eastbound through a location affectionately known as 'Big Tree' in Elliston, VA. Taken on 27 October 2017.

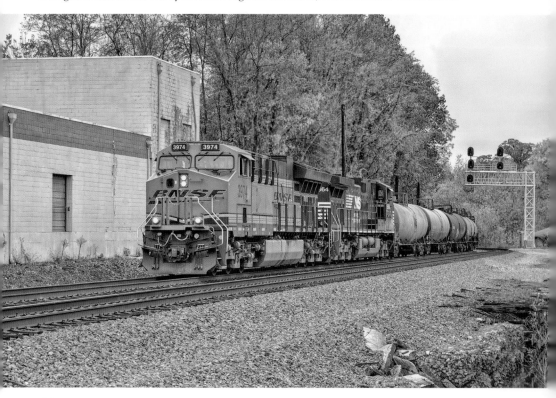

BNSF GE ET44C4 No. 3924 is on the point of NS No. 194 as it heads through Christiansburg, VA. Taken on 1 November 2017.

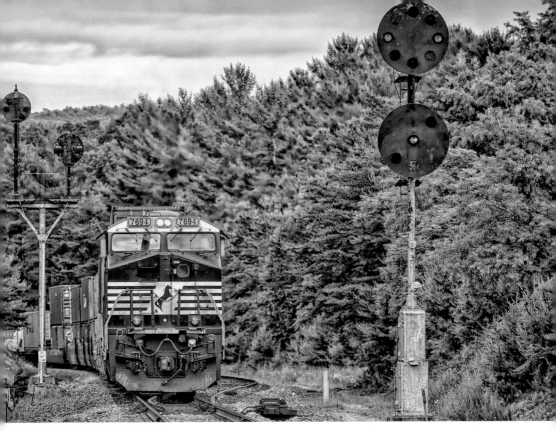

Norfolk Southern GE ES44DC No. 7694 splits the classic N&W signals at Gunton Park as it heads a priority westbound intermodal at Max Meadows, VA. Taken on 8 June 2017.

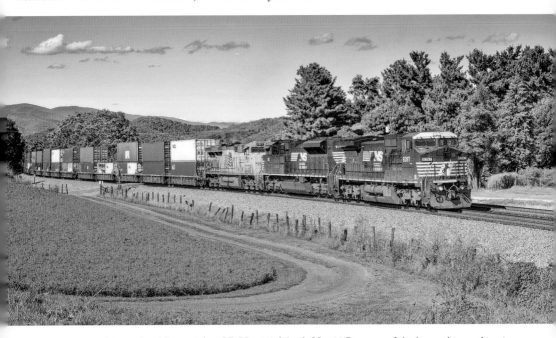

Norfolk Southern GE Dash-8 No. 8397 (ex-CR No. 6191) leads No. 29G at one of the better-known locations along the NS Christiansburg District in Shawsville, VA. Taken on 5 August 2017.

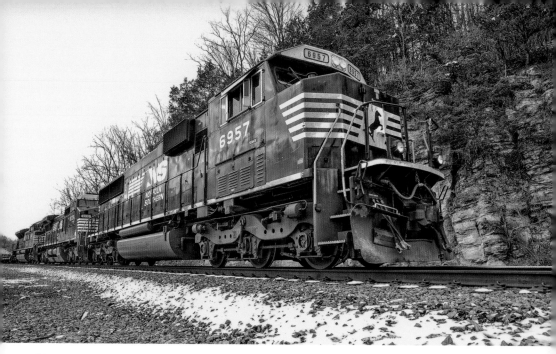

The blunt angles and overhanging brow of the NS-designed 'Crescent Cab' on the EMD SD60E are evident in this 20 mm lens view as SD60E No. 6957 (ex-NS SD60 No. 6614) leads No. 16T through Radford, VA on the Pulaski District. Taken on 13 March 2018.

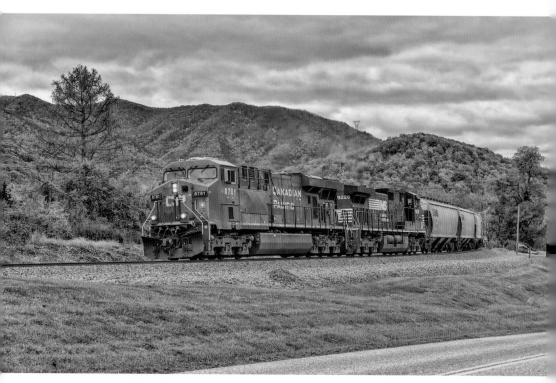

Canadian Pacific GE ES44AC No. 8781 and an NS Dash-9 are the motive power for grain train No. 52V as it heads through a location known as Riverside. This train is on the former Virginian Railway main line in Wabun, VA. Taken on 29 October 2017.

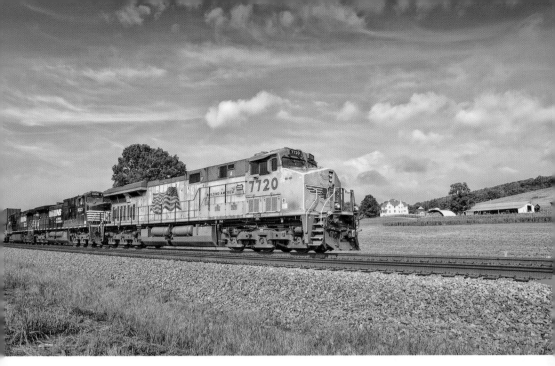

With Union Pacific GE AC45CCTE No. 7720 leading two NS Dash-9s, Norfolk Southern No. 236 motors eastbound through Shawsville, VA. Taken on 14 March 2018.

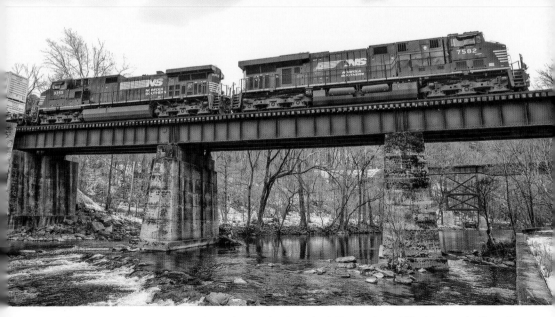

Two Norfolk Southern GE variants – an ES44DC and a Dash-9 – lead Chicago-bound No. 217 over the Roanoke River in Wabun, VA

West Virginia

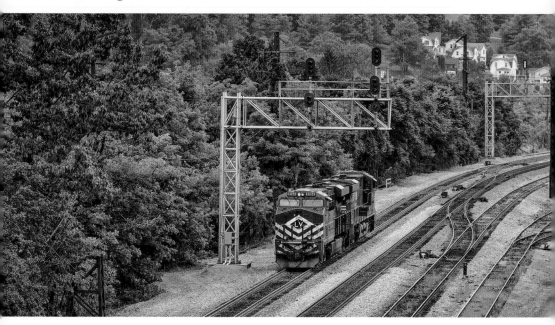

After helping a coal drag into Bluefield Yard, two GE ES44AC units in pusher service head back westbound for another assist up the grade. The trailing unit is one of twenty Norfolk Southern engines that are known as heritage units; namely, engines that are painted in NS predecessor paint schemes to honor Norfolk Southern's 30th anniversary. Taken in Bluefield, WV on 7 August 2016.

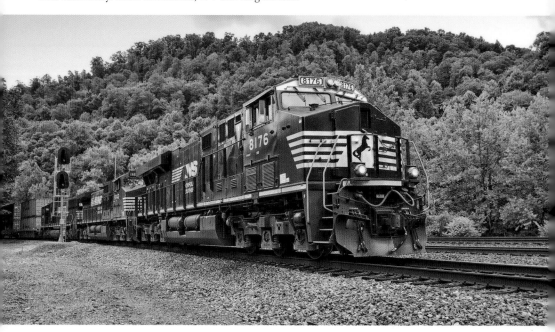

NS GE ES44AC No. 8176 splits the new replacement signals at Capels, WV with Chicago, IL-bound intermodal train No. 217. Taken on 26 July 2017.

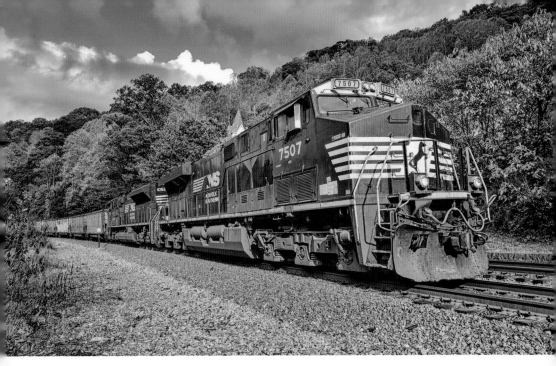

Just after sunrise, Norfolk Southern General Electric ES44DC No. 7507 is captured leading eastbound coal train No. 83A through Elkhorn, WV. Taken on 14 October 2017.

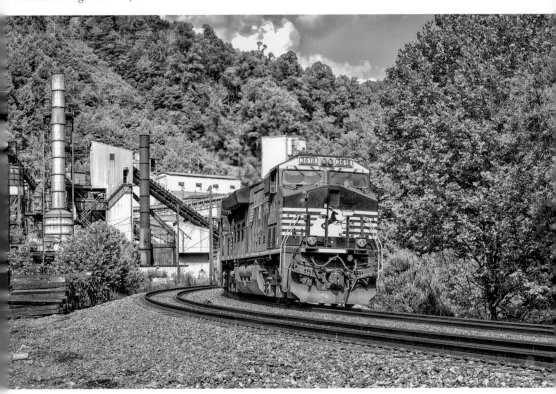

One of Norfolk Southern's newest editions to the fleet, GE ET44AC No. 3618, leads a westbound train past one of the old coal mines located along the Pocahontas District. Taken in Keystone, WV on 26 July 2017.

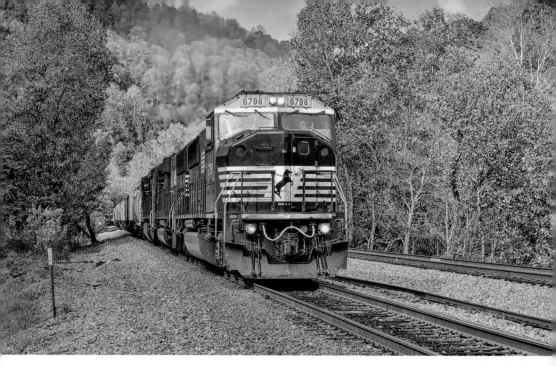

NS EMD SD60M No. 6798 (ex-Conrail No. 5560, which was acquired during the Conrail merger in 1999) is seen heading through Northfork, WV with eastbound manifest train No. 188. Taken on 14 October 2017.

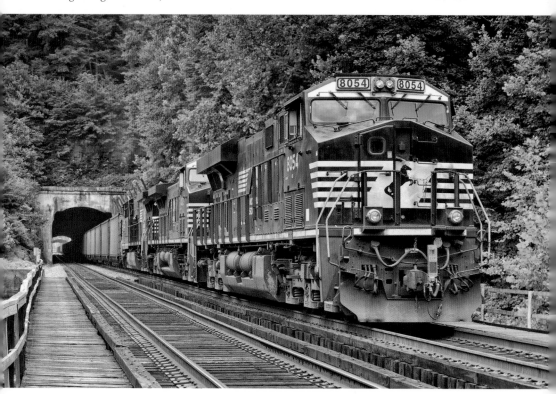

A trio of NS GE AC traction motors are on the rear of an eastbound coal drag as it ducks into Hemphill Tunnel in Capels, WV. Taken on 26 July 2017.

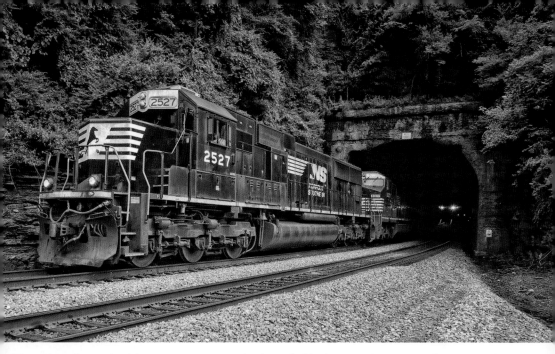

Non-safety cab or widecab locomotives are getting harder to find leading main line trains as the years march on. In this view, we are treated to NS EMD SD70 No. 2527 leading a former Conrail GE Dash-40CW out of Welch Tunnel with a westbound manifest. Taken in Welch, WV on 26 July 2017.

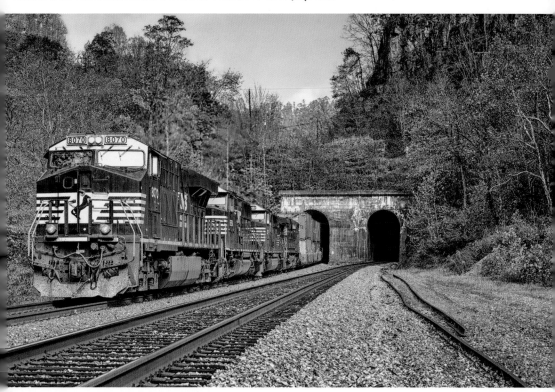

NS GE ES44AC No. 8070 leads Chicago, IL–Norfolk, VA intermodal No. 234 out of Huger Tunnel in Superior, WV. Taken on 14 October 2017.

Look closely and you will find NS EMD SD70ACe No. 1111 heading eastbound as it crosses the Tug Fork River in downtown Welch, WV. This overall shot gives a good idea of the landscape of the Pocahontas District in West Virginia. Taken on 14 October 2017.

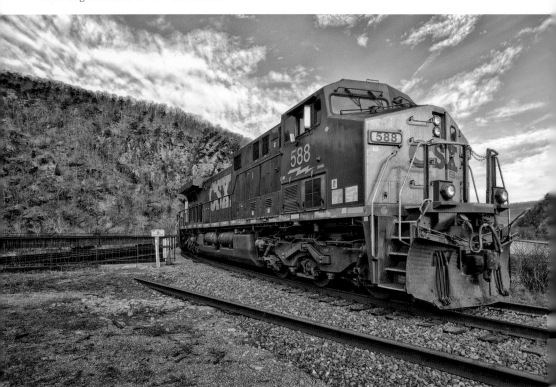

An in-your-face look at CSX GE-built AC44CW No. 588 as it leads ballast train No. W061-15 on to the Shenandoah Sub in Harpers Ferry, WV. Taken on 15 February 2018.

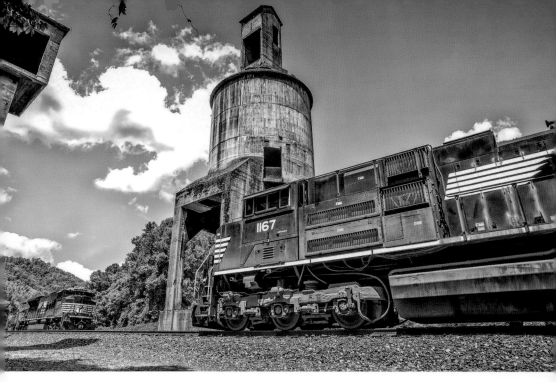

A time warp as modern EMD AC traction motors pass a symbol of steam railroading in the form of an old Norfolk & Western coaling tower. Taken in Capels, WV on 26 July 2017.

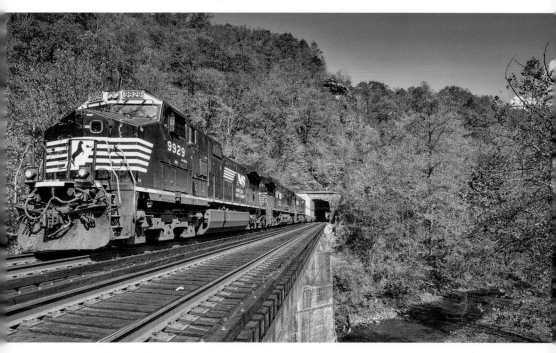

For many years the General Electric Dash-9 was a ubiquitous sight on Norfolk Southern rails, with the railroad owning just over 1,000 examples of the model. They are slowly starting to be rebuilt by NS and GE shop forces into new AC44C6M AC traction engines. One of the higher-numbered Dash-9s leads No. 233 over the Tug Fork River in Roderfield, WV. Taken on 14 October 2017.

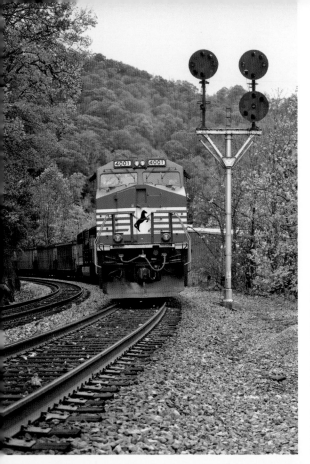

Left: Originally built by GE as Dash 9-40C No. 8879, rebuilt NS AC44C6M No. 4001 in a special scheme passes a former Norfolk & Western position light signal on the outskirts of Welch, WV. Since this photograph was taken, No. 4001 was damaged in a wreck, and the N&W signals have fallen victim to the government-mandated PTC signal upgrade. Taken on 21 October 2016.

Below: Months old NS GE ET44AC No. 3620 leads No. 272 as it ducks under a now replaced classic N&W era signal bridge in Landgraff, WV. Taken on 22 October 2016.

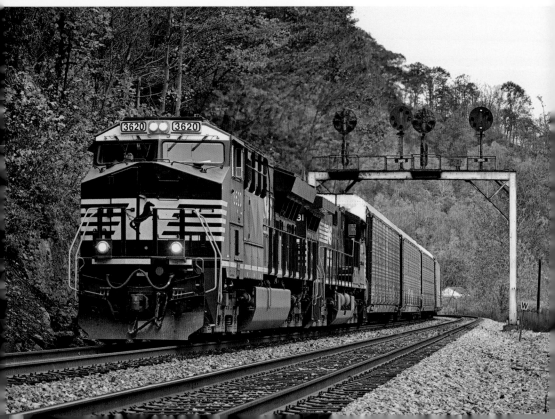

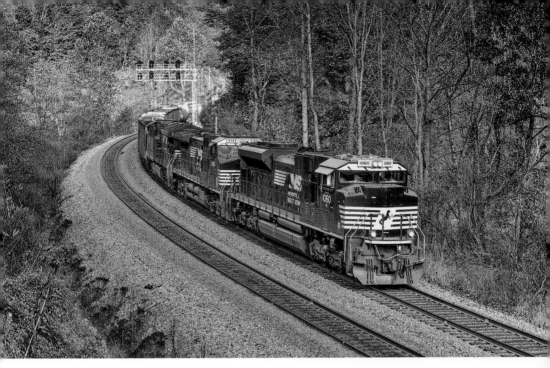

NS EMD SD70ACe No. 1060 leads eastbound manifest No. 194 through Switchback, WV, just after sunrise on 14 October 2017.

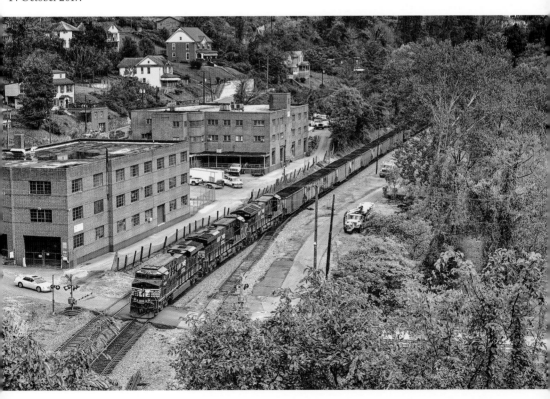

Three NS AC traction GEVOs shove an eastbound load of black diamonds through Welch, WV. Taken on 23 October 2016.

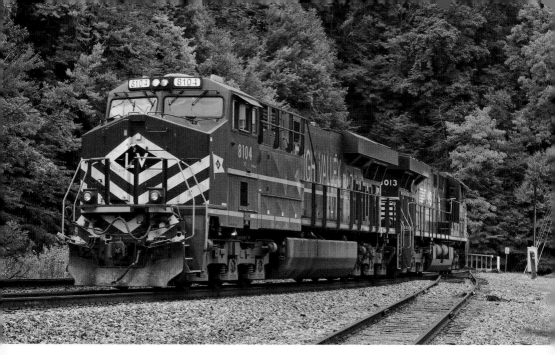

On the evening of 6 August 2016, one of Norfolk Southern's twenty heritage units trails a westbound helper move at Kimball, WV. This General Electric ES44AC honors the Lehigh Valley Railroad, which ceased operations in 1976 as part of the formation of Conrail. Conrail was split between NS and CSX in 1999.

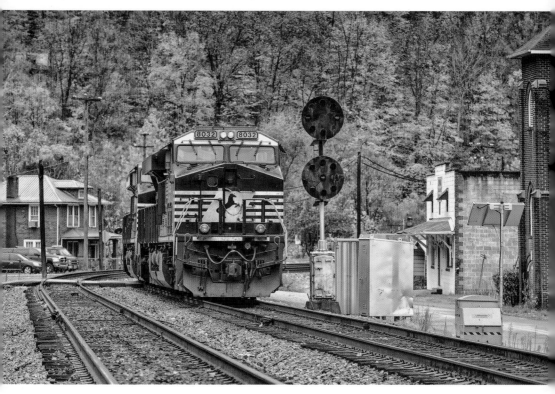

2010-built NS GE ES44AC No. 8032 passes a now removed N&W signal as it heads eastbound with a helper move. Taken on 22 October 2016.

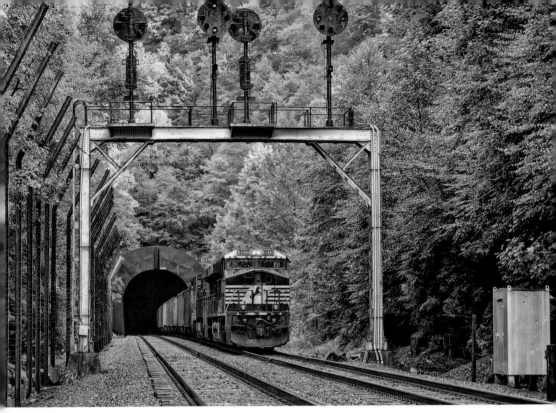

Elkhorn Tunnel in Maybeury, WV is one of the revered railfan locations along the Pocahontas Division. While the classic N&W signal bridge may be gone now, scenes like this, with modern GE ES44AC locomotives shoving loads of coal over the grade, are still repeated dozens of times a day. Taken on 6 August 2016.

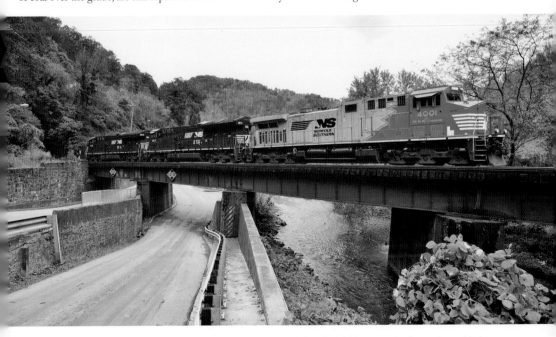

Former GE Dash 9-40C No. 8879, rebuilt in-house by NS as AC44C6M No. 4001, leads westbound helper move No. J67 over the Tug Fork River in Welch, WV. Taken on 22 October 2016.

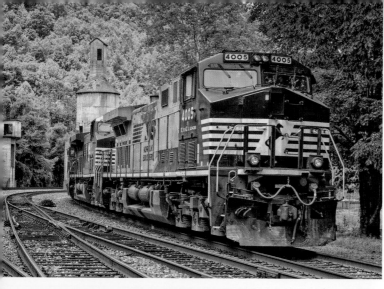

'Blue Mane' scheme-painted NS GE AC44C6M No. 4005 (ex-NS D9-40C No. 8867) leads a helper set through Capels, WV on the Pocahontas Division. Taken on 14 July 2018.

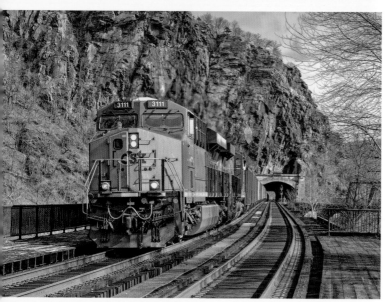

In the latest version of the railroad's paint scheme, CSX GE ES44AC-H No. 3111 leads westbound No. E783-15 out of the tunnel at iconic Harpers Ferry, WV. Taken on 15 February 2018.

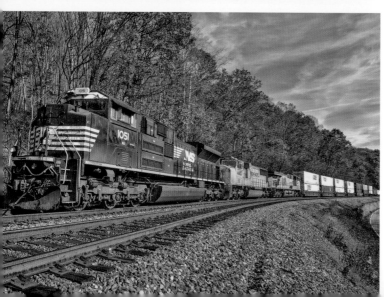

Norfolk Southern EMD SD70ACe No. 1051 and two Union Pacific units lead westbound intermodal train No. 233 through Oakvale, WV. Taken on 11 November 2017.

South Carolina

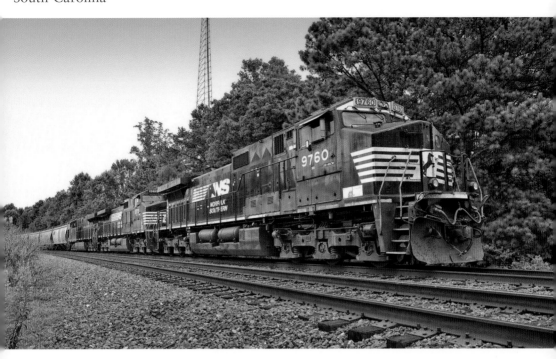

Norfolk Southern GE D9-44CW No. 9760 is leading No. 50V down the ex-Southern R Line in Fort Mill, SC. A keen eye will spot the N&W heritage ES44AC trailing behind the two Dash-9s. Taken on 3 August 2017.

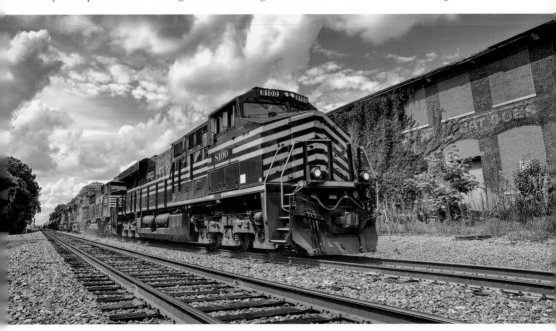

Norfolk Southern GE ES44AC No. 8100, painted in the heritage scheme of the Nickel Plate Road, pulls through Hayne Junction in Spartanburg, SC with northbound manifest No. 154. Taken on 13 August 2017.

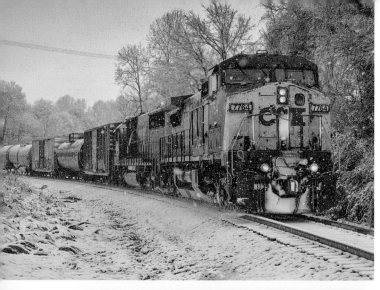

CSX GE D8-40CW No. 7764 leads southbound No. Q619 through Van Wyck, SC on the Monroe Sub as a rare dusting of snow falls in the Carolinas. Taken on 12 March 2017.

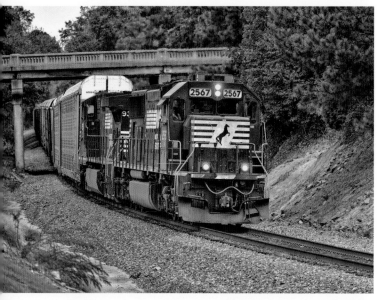

An ex-Conrail EMD SD70 is on the point of a rerouted No. 28T as it heads through Fort Mill, SC on the R Line. Taken on 25 October 2015.

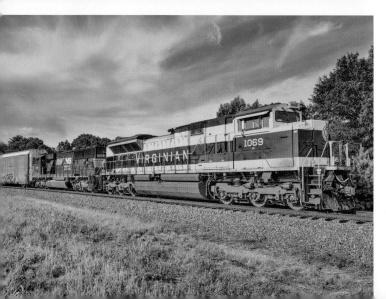

Virginian heritage EMD SD70Ace No. 1069 is on the point of No. 28T as it heads towards Columbia, SC on the W Line. Taken in Spartanburg, SC on 13 August 2017.

Maryland

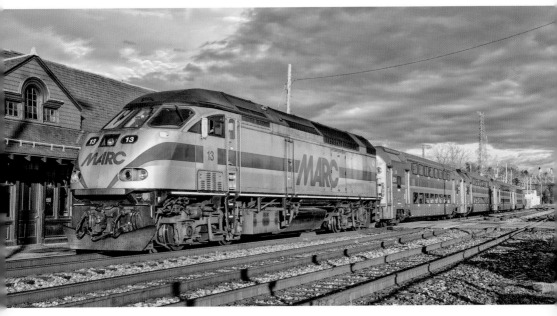

MARC MPI-built MP36PH-3C No. 13 stops at Brunswick, MD with a late afternoon westbound local from Washington DC. Taken on 15 February 2018.

New Jersey

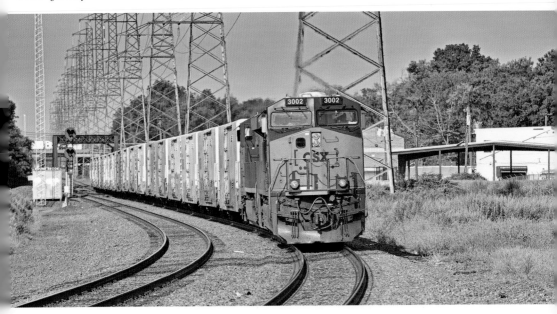

With a short load of Tropicana orange juice reefers behind it, CSX GE ES44AC-H No. 3002 leads northbound unit train No. Q740 through Bound Brook, NJ on the joint NS/CSX Lehigh Line. Taken on 29 July 2015.

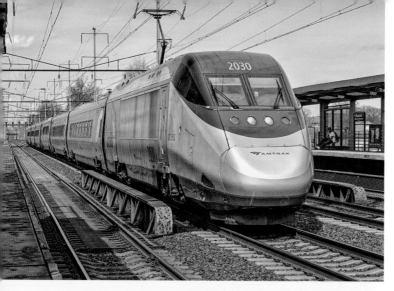

One of Amtrak's high-speed Acela trainsets blasts through Elizabeth, NJ as it heads to Washington, DC. The former Pennsylvania Railroad Northeast Corridor is one of the busiest stretches of track in the entire United States. Taken on 11 April 2017.

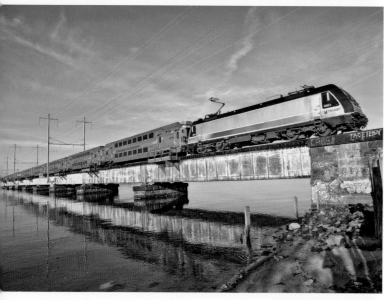

New Jersey Transit Bombardier-built ALP46A No. 4661 crosses the Raritan River in Perth Amboy, NJ as it leads a New York-bound morning express train. Taken on 10 April 2017.

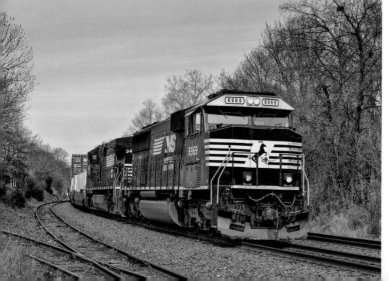

The EMD SD60E is a model unique to Norfolk Southern. Starting in 2010, NS upgraded older SD60s to modern specs. Here we see SD60E No. 6969 (ex-NS SD60 No. 6681) leading No. 24Z through Piscataway, NJ on the Lehigh Line. Taken on 13 April 2017.

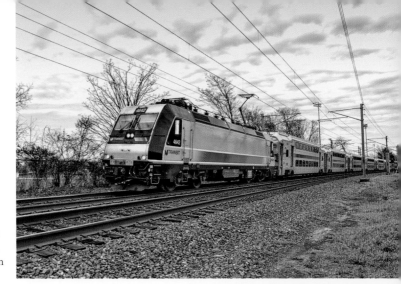

New Jersey Transit operates a vast network of commuter lines throughout New Jersey on former CNJ, EL, PRSL and PRR trackage. Here we see NJT ALP46 No. 4642 leading a Long Branch-bound local train through Red Bank, NJ. Taken on 14 April 2017.

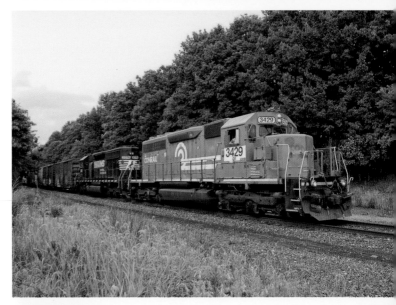

Norfolk Southern EMD SD40-2R No. 3429 was originally built as Kansas City Southern No. 612 back in 1966. It was acquired by Conrail and became their No. 6966 after a rebuild. We catch it heading through Parlin, NJ on the ex-PRR Amboy Secondary, leading No. OI-16. Taken on 18 July 2011.

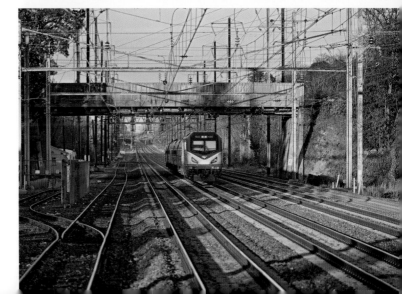

Amtrak's latest motive power, the Siemens-built ACS-64, is on the point of a Harrisburg, PA-bound Keystone Service train as it heads through Princeton Junction, NJ on 15 November 2015.

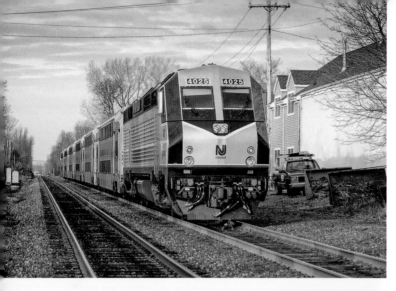

New Jersey Transit PL42-AC No. 4025, which was built by Alstom in 2005, is shown shoving a Bayhead–Long Branch shuttle train on New Year's Day 2010 in Spring Lake, NJ.

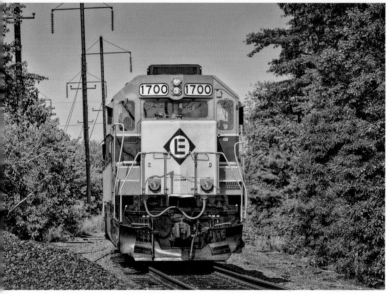

Norfolk Southern surprised railfans in 2015 when it painted one of their classic EMD ex-EL SD45-2s back into the original EL scheme. NS No. 1700 (ex-CR No. 66554, ex-EL No. 3669) is seen leading No. OI-16 on the Amboy Secondary in Parlin, NJ on 29 July 2016.

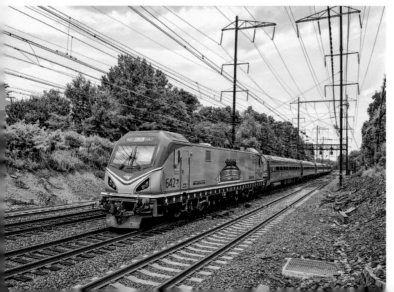

Amtrak ACS-64 No. 642 is dressed in a special scheme that honors US veterans. It is seen shoving a New York-bound Keystone service train through Metuchen, NJ on 28 July 2016.

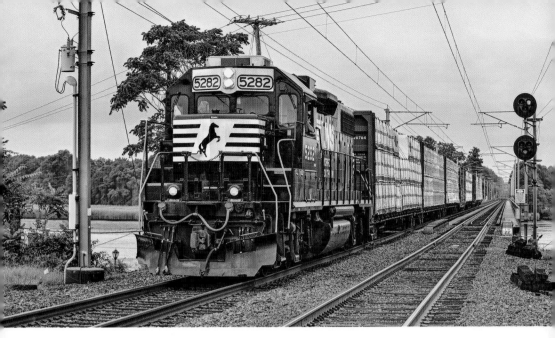

Norfolk Southern and CSX provide some local freight operations over NJ Transit lines. Norfolk Southern EMD GP38-2 No. 5282 (built in 1973 as Penn Central No. 8079) leads No. SA31 over the Navesink River in Red Bank, NJ. This train will swing off the main line just ahead and take the old route of the CNJ Blue Comet towards Lakehurst, NJ. Taken on 30 July 2015.

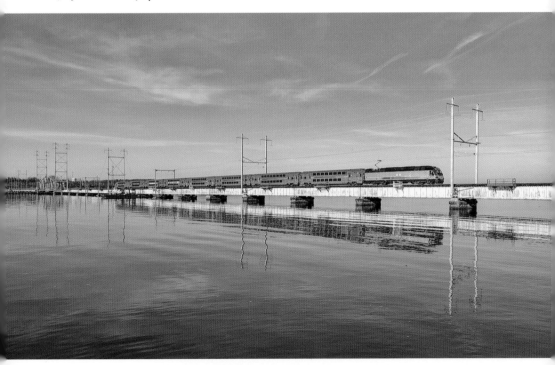

New Jersey Transit's fleet of dual-mode ALP45-DP locomotives, built by Bombardier Transportation, allow a one-seat ride into New York Penn station as they can operate in both diesel mode and electric mode, allowing maximum versatility. NJT ALP45-DP No. 4529 crosses the Raritan River in Perth Amboy, NJ with a morning New York-bound local. Taken on 11 April 2017.

Georgia

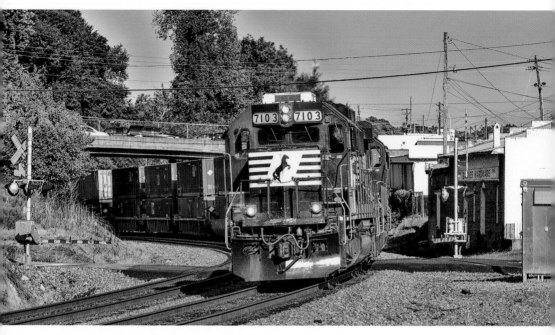

Norfolk Southern EMD GP60 No. 7103 leads a string of stacks headed to the intermodal yard in Austell, GA on the Atlanta North District. Taken in Mableton, GA on 7 September 2017.

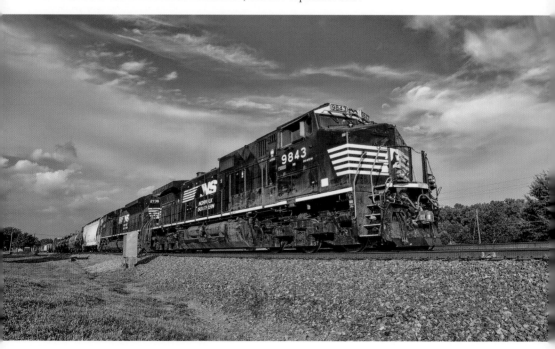

Norfolk Southern GE Dash 9-44CW No. 9843 leads local turn No. G53 through Flowery Branch, GA on the NS Greenville District. Taken on 26 August 2017.

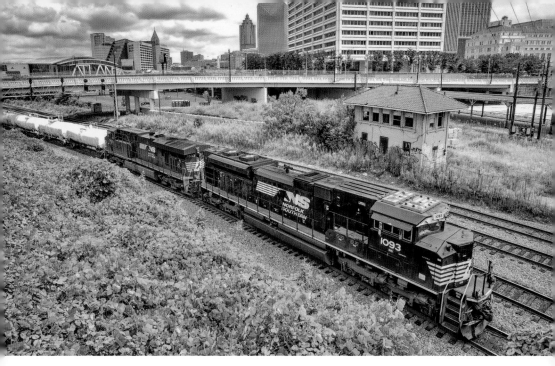

Norfolk Southern EMD SD70ACe No. 1093 leads No. 119 past the long-closed Spring tower as it leaves downtown Atlanta. Taken on 26 August 2017.

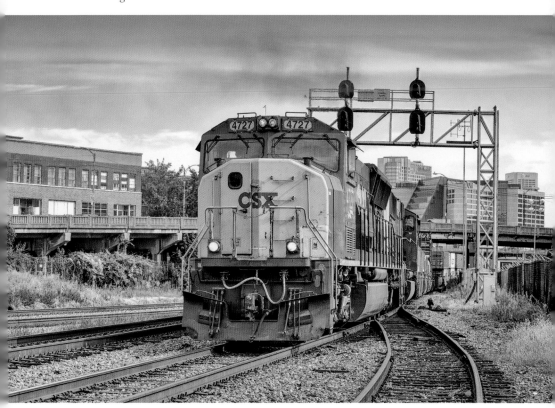

CSX EMD SD70MAC No. 4727 leads No. Q145 out of downtown Atlanta. Taken on 26 August 2017.

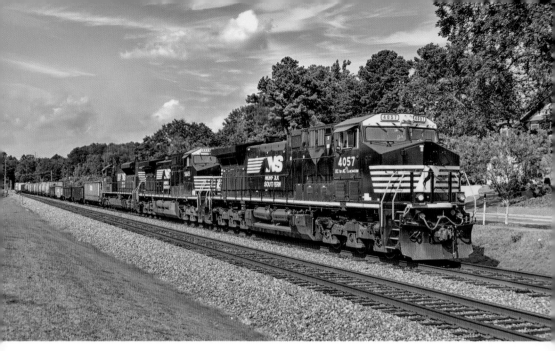

Norfolk Southern recently started upgrading their older GE Dash-9s to AC44C6M models. Recently rebuilt AC44C6M No. 4057 (ex-NS D9-40C No. 8791) leads southbound No. 153 through Buford, GA on the Greenville District. Taken on 27 August 2017.

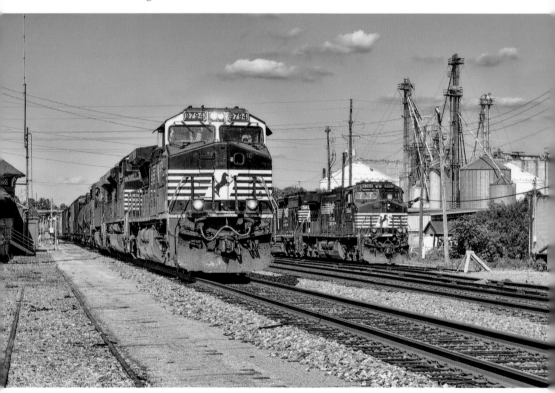

Seen passing the Amtrak station and some local power, Norfolk Southern GE Dash 9 No. 9794 leads southbound No. 173 through Gainesville, GA on the Greenville District. Taken on 8 September 2017.

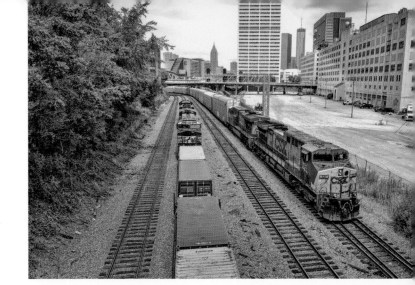

Inbound NS No. 231 meets CSX No. Q235 in downtown Atlanta. The CSX train is led by 1996-built GE AC44CW No. 131. Taken on 26 August 2017.

NS RP-M4C Eco Slug No. 655 and GP33ECO No. 4717 lead transfer run No. GE07 into downtown Atlanta. Both units wear a special scheme promoting the 'green' lower emissions of the rebuilt locomotives. Taken on 27 August 2017.

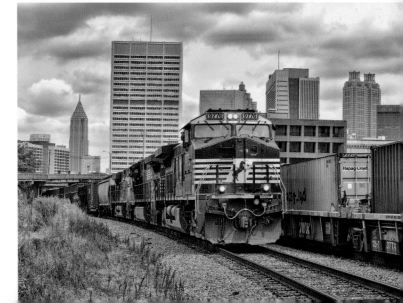

With the skyline in the background, Norfolk Southern D9-44CW No. 9776 passes an inbound intermodal as it leads southbound No. 177 out of Atlanta. Taken on 26 August 2017.

North Carolina

Norfolk Southern GE Dash 9-44CW No. 9546 leads No. P99 through Graham Interlocking and past the ADM plant as it heads towards the Charlotte, NC intermodal terminal. Taken on 11 February 2018.

In 2010, Norfolk Southern embarked on a program to upgrade their older EMD SD60 locomotives to modern criteria, which included a now standard safety cab. One of those engines was specially painted to honor the first responders of the United States. SD60E No. 911 (ex-NS SD60 No. 6577) is on the point of Atlanta-bound No. 119 as it heads south through Charlotte Junction on the Piedmont Division. Taken on 10 March 2016.

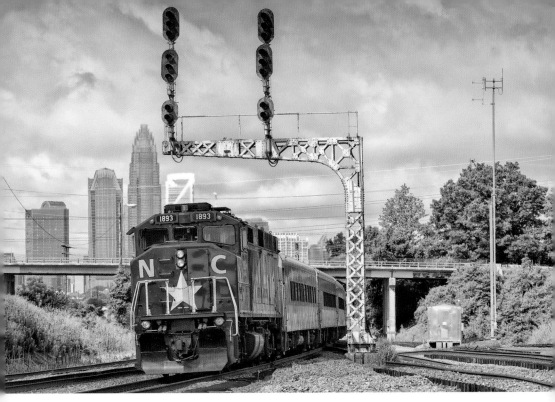

In conjunction with Amtrak, the North Carolina Department of Transportation operates serval round trip passenger trains between Charlotte and Raleigh, NC. NCDOT/Amtrak EMD F59PH No. 1893 shoves Amtrak No. 73 under the now replaced Southern signals at CP AT&O, just outside of Charlotte Yard. Taken on 4 July 2017.

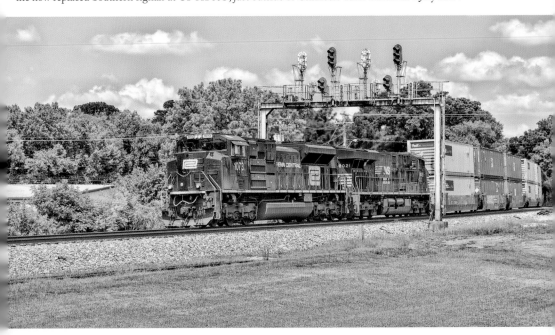

Norfolk Southern EMD SD70ACe No. 1073, painted in the heritage scheme of predecessor Penn Central, ducks under one of the few remaining Southern Railway era signal bridges on the Piedmont Division as it leads Rutherford, PA-bound No. 204 through Lowell, NC. Taken on 29 July 2017.

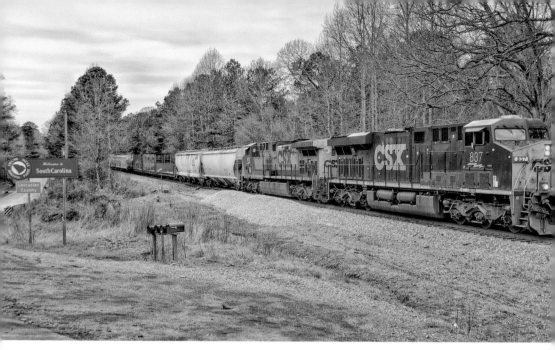

CSX No. Q610 crosses the state line from SC into NC on the Monroe Sub with CSX GE-built ES44AC-H No. 837 leading. Taken on 25 February 2018 in Waxhaw, NC.

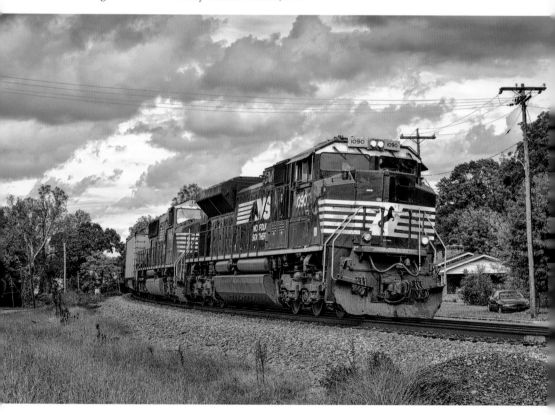

Norfolk Southern EMD SD70ACe No. 1090 leads southbound manifest No. 159 through Reidsville, NC on the Danville District. Taken on 9 October 2017.

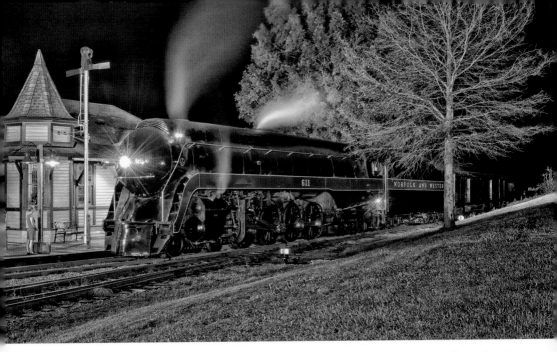

In a scene inspired by famed rail photographer O. Winston Link, N&W J Class No. 611 arrives into Barber Junction with a late-night Powhatan Arrow during a night photo event at the North Carolina Transportation Museum. Taken on 1 September 2018.

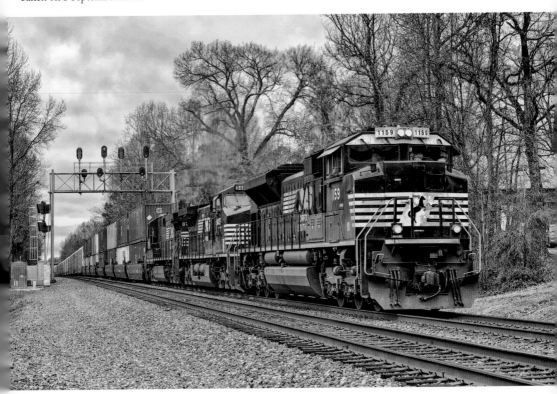

NS EMD SD70ACe No. 1159 is seen leading New Jersey-bound intermodal No. 212 under the now replaced Southern era signals at milepost 330 on the Piedmont Division in Spencer, NC. Taken on 27 December 2015.

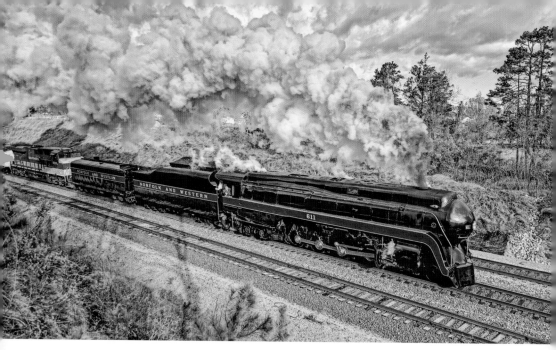

Norfolk & Western J Class No. 611 steams through Jamestown Cut as it leads a round trip excursion from Spencer, NC to Lynchburg, VA. The Southern ES44AC heritage unit and a Southern F unit are along for the ride. Taken in Jamestown, NC on 9 April 2016.

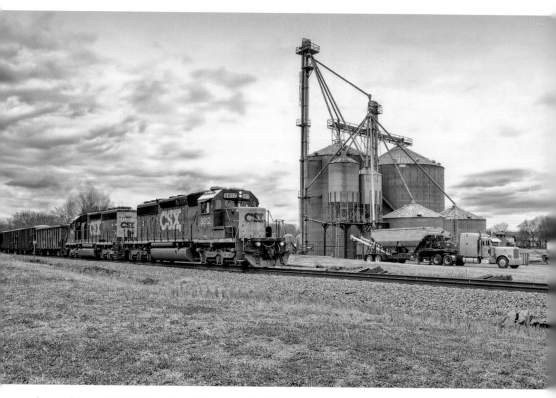

A pair of classic EMD SD40-2s lead ballast train No. W086 past Frank Howey Farms in Houston, NC on the CSX Monroe Sub. The lead unit was originally built for Conrail as CR No. 6391 in 1977. Taken on 26 January 2018.

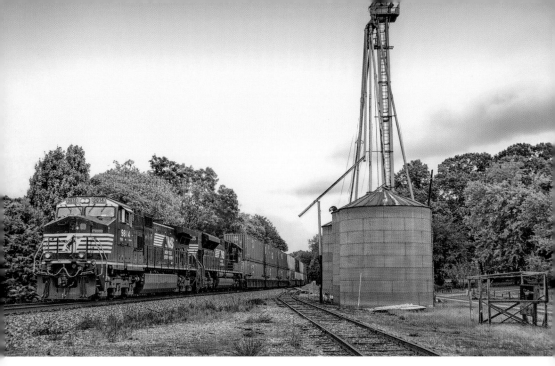

Norfolk Southern GE Dash 9-44CW No. 9814 leads Chicago, IL–Linwood, NC No. 218 southbound through rural Ruffin, NC on the Danville District. Taken on 9 October 2017.

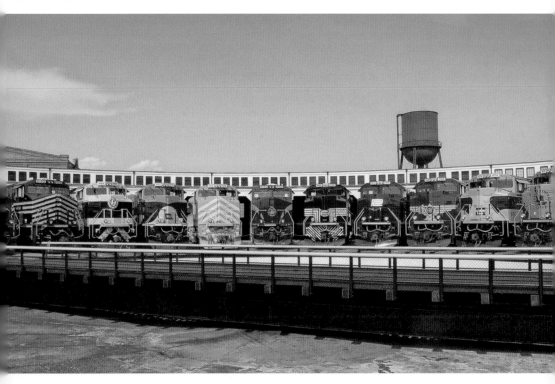

To celebrate their 30th anniversary, Norfolk Southern painted twenty GE and EMD diesels in the schemes of their predecessor roads. NS assembled all the units at the North Carolina Transportation Museum in Spencer, NC for a photo shoot. Eleven of the twenty units are shown in this shot, which was taken on 4 July 2012.

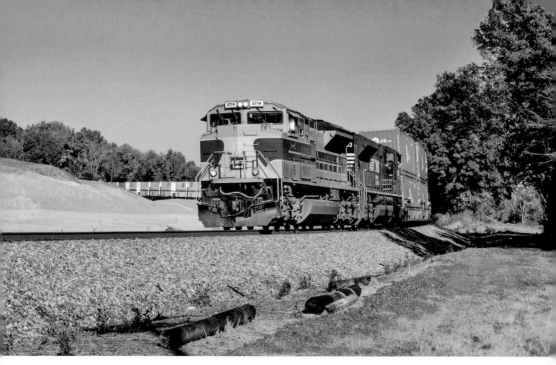

NS SD70ACe No. 1074, painted in the heritage scheme of the Lackawanna Railroad, leads Linwood–Charlotte, NC No. P99 through Harrisburg, NC on the Piedmont Division. Taken on 27 October 2013.

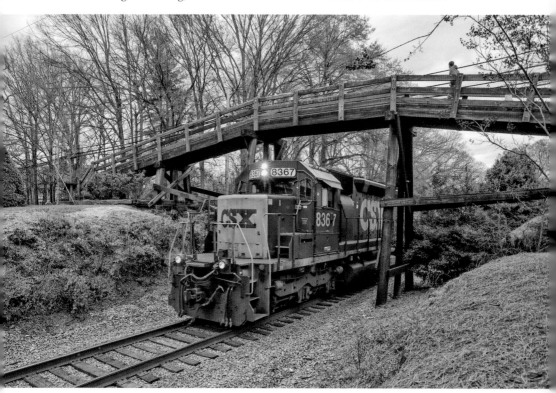

CSX EMD SD40-2 No. 8367 (ex-C&O No. 7508) soldiers on as it ducks under the classic pedestrian bridge in Waxhaw, NC, leading No. G968 on the Monroe Sub. Taken on 24 March 2016.

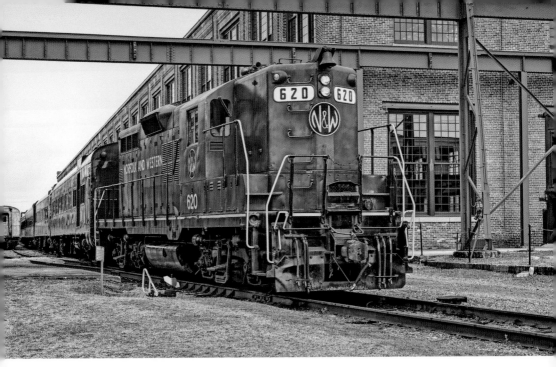

Former Norfolk & Western EMD GP9 No. 620 now works excursion services at the North Carolina Transportation Museum in Spencer, NC. Taken on 5 March 2016.

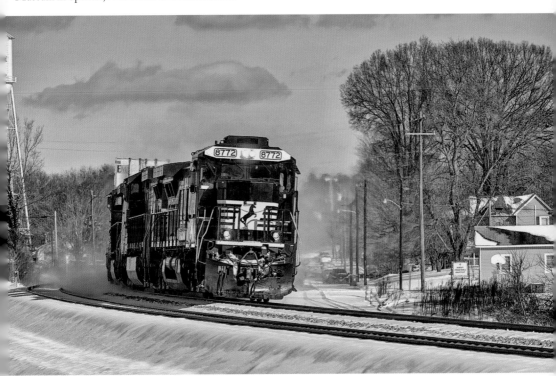

Currently being rebuilt to AC44C6M units, a non-safety cab Dash-9 is tough to find on the point of a main line freight. NS GE D9-40C No. 8772 kicks up the fresh snow as it flies southbound through China Grove, NC with Atlanta-bound No. 213. Taken on 17 January 2017.

Far away from normal surroundings, Union Pacific EMD SD70M No. 3825 is captured leading Crewe, VA-bound No. 158 up the Danville District in Sadler, NC. Taken on 9 October 2017.

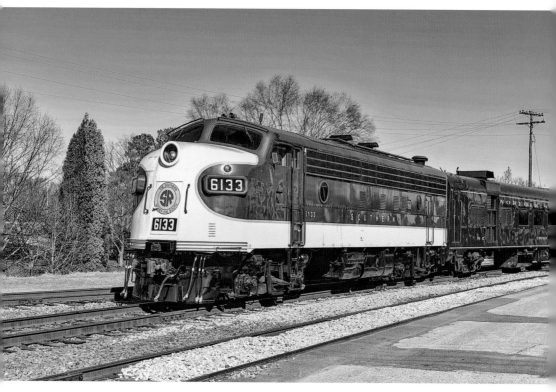

Former Southern EMD FP7A No. 6133 lives a second life pulling excursions for the North Carolina Transportation Museum in Spencer, NC. Taken on 30 January 2017.

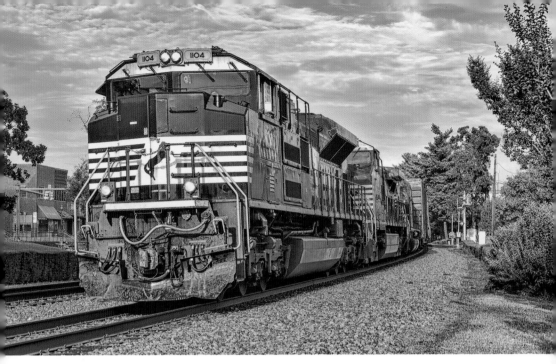

Norfolk Southern EMD SD70ACe No. 1104 is seen leading No. 13R from Enola, PA as it heads through Thomasville, NC. Taken on 9 October 2017.

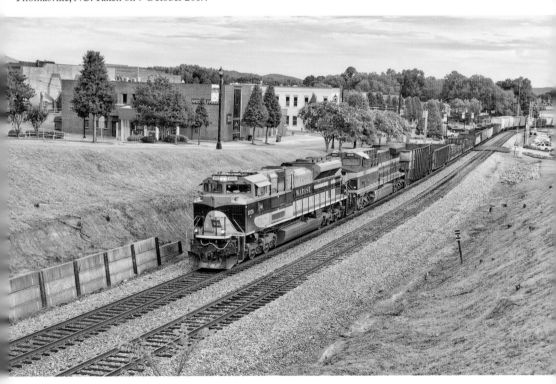

Norfolk Southern SD70ACe No. 1070, dressed in the heritage colors of the Wabash Railroad, leads a Kansas City Southern GE AC44CW as it heads northbound through Kings Mountain, NC with manifest No. 154. Taken on 2 July 2017.

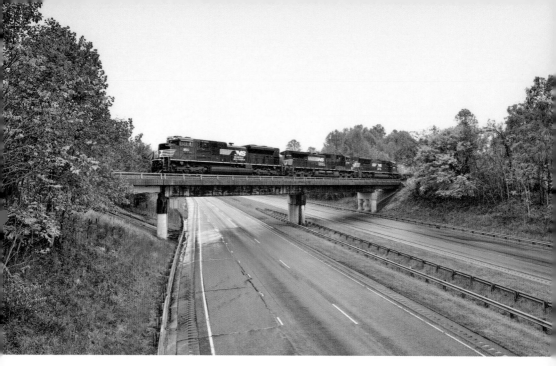

NS SD70ACe No. 1160 leads northbound No. 165 over US 29 in Ruffin, NC on the Danville District. Taken on 1 October 2017.

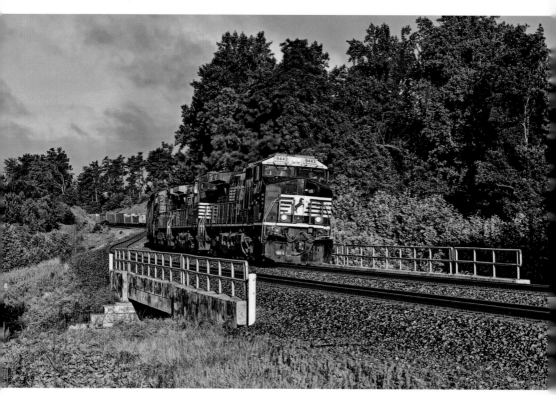

Norfolk Southern GE Dash 9-44CW No. 9443 gleams in the early morning sun as it rounds the S curve in Jamestown, NC with Allentown, PA-bound No. 36Q. Taken on 7 June 2016.

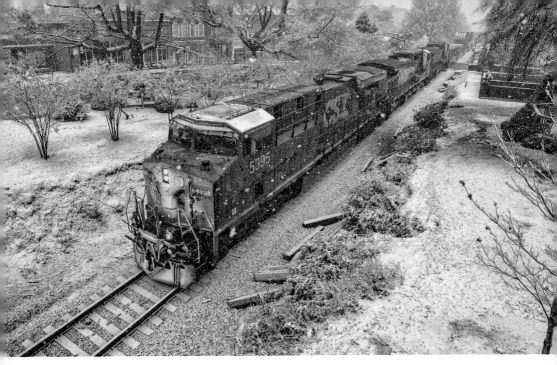

CSX ES44DC No. 5395 leads No. Q581 through Waxhaw, NC on the Monroe Sub during a rare snowstorm in the Carolinas. Taken on 17 January 2018.

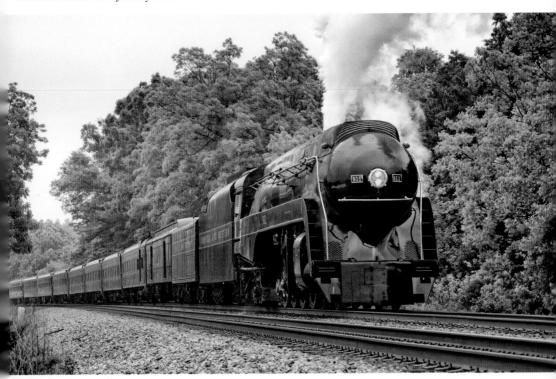

Just after restoration, Norfolk Southern sent N&W No. 611 out on a shakedown run along the Piedmont Division before heading back to Roanoke. The test train is seen here heading southbound at Thomasville, NC. Taken on 21 May 2015.

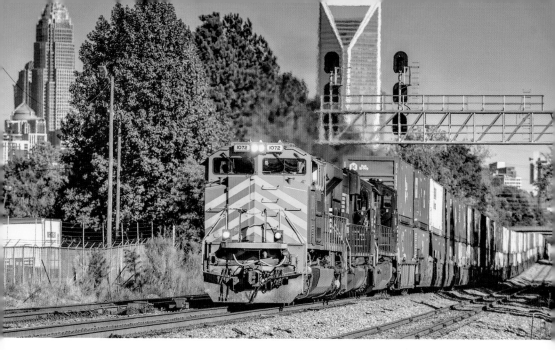

Nicknamed the 'Jolly Green Giant' by railfans, NS EMD SD70ACe No. 1072, painted in the heritage colors of the Illinois Terminal, leads southbound No. P99 through Charlotte Junction. Taken on 23 October 2016.

Pennsylvania

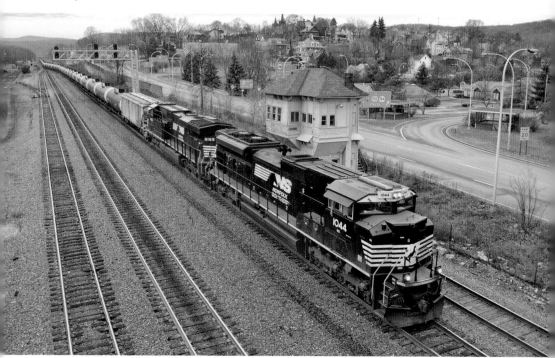

Norfolk Southern EMD SD70ACe No. 1044 and GE ES44AC No. 8165 bring Reybold, DE-bound No. 66X past the now closed ALTO tower and into downtown Altoona, PA. Taken on 23 November 2014.

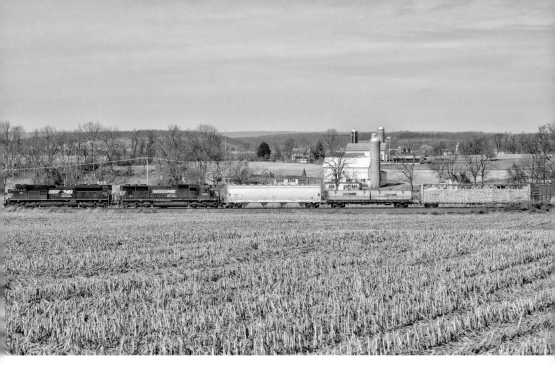

Norfolk Southern EMD SD70ACe No. 1171 and EMD SD70 No. 2525 lead a westbound manifest past one of the many farms that dot the landscape in this area of eastern Pennsylvania. Taken in Topton, PA on 17 February 2018.

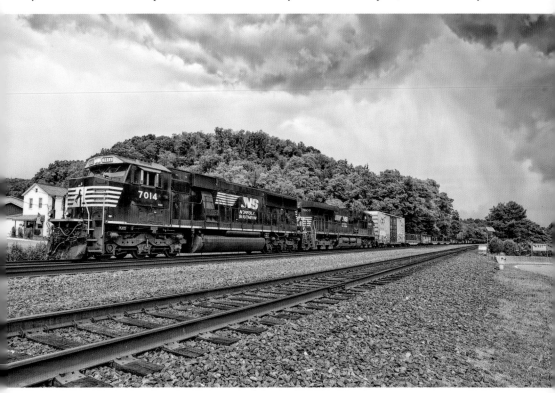

Norfolk Southern SD60E No. 7014 (rebuilt from NS SD60 No. 6682) tries to outrun a summer thunderstorm as it heads through Summerhill, PA with westbound No. 19G. Taken on 8 July 2017.

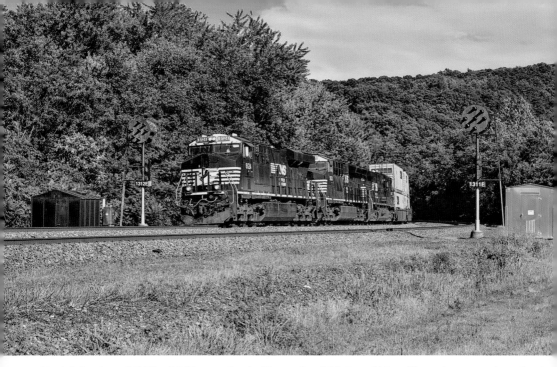

Norfolk Southern GE ES44AC No. 8124 hustles Kansas City, MO-bound No. 21T past the soon to be replaced PRR era signals at Newport, PA on the Pittsburgh Line. Taken on 22 July 2016.

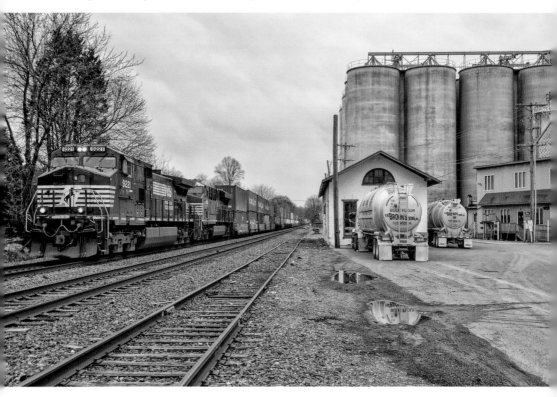

Norfolk Southern GE D9-44CW No. 9221 is on the point of New Jersey-bound No. 20K as it passes through Fleetwood, PA on the Reading Line. Taken on 17 February 2018.

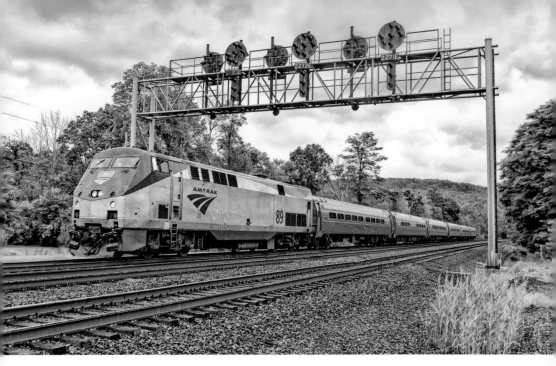

One of Amtrak's ubiquitous GE P42 Genesis locomotives leads the Pittsburgh-bound Pennsylvanian under the PRR signals at Fostoria, PA on the Pittsburgh Line. Taken on 7 October 2017.

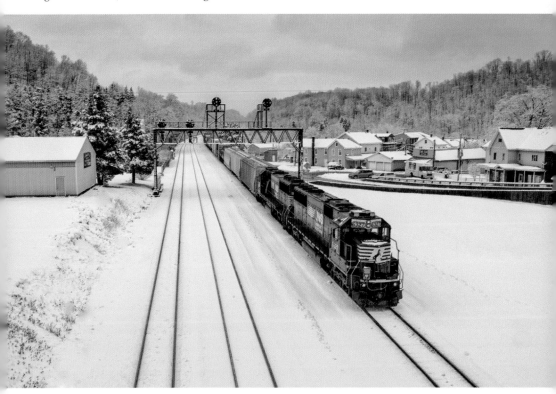

Norfolk Southern EMD SD40E helpers shove No. 16N eastbound under the old PRR signals at Summerhill, PA. NS No. 6327 is ex-CR SD50 No. 6737. Taken on 24 January 2015.

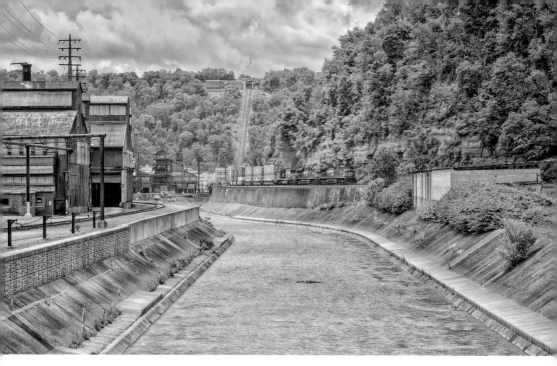

NS No. 20T skirts the banks of the Conemaugh River in Johnstown, PA with GE-built Dash-9 No. 9159 leading. Taken on 8 July 2017.

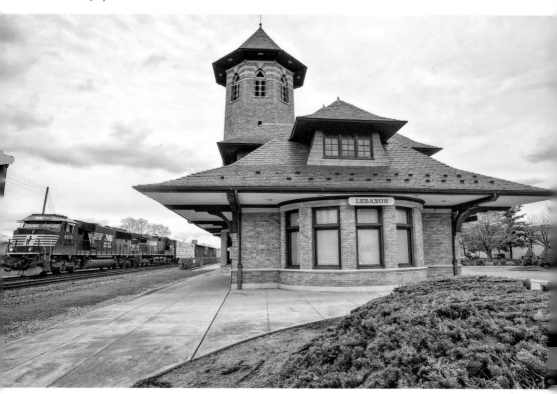

Norfolk Southern EMD SD60E No. 6979 (rebuilt from NS SD60 No. 6642) passes the former Reading Railroad passenger station in Lebanon, PA with Allentown, PA–Birmingham, AL manifest No. 15T. Taken on 16 February 2018.

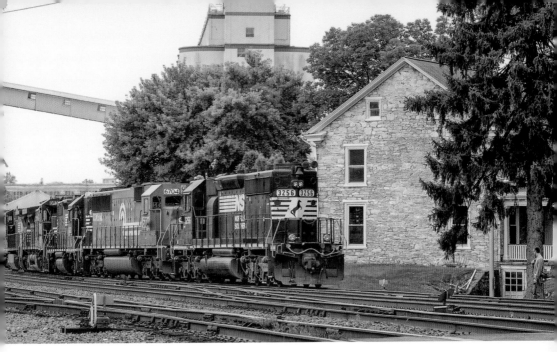

Norfolk Southern EMD SD40-2 No. 3256 (ex-Southern No. 3256), a former Conrail EMD SD60 and other engines do some switching around the Hershey chocolate factory in Hershey, PA on the Harrisburg Line. Taken on 9 September 2009.

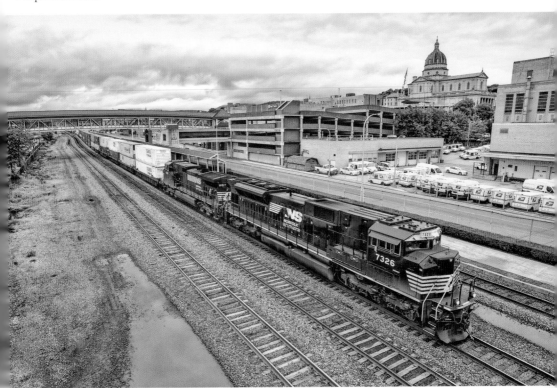

Rebuilt EMD SD70ACU No. 7326 leads No. 294 eastbound through downtown Altoona on the Pittsburgh Line. No. 7326 was originally built for Union Pacific as SD90MAC No. 8259. Taken on 6 July 2017.

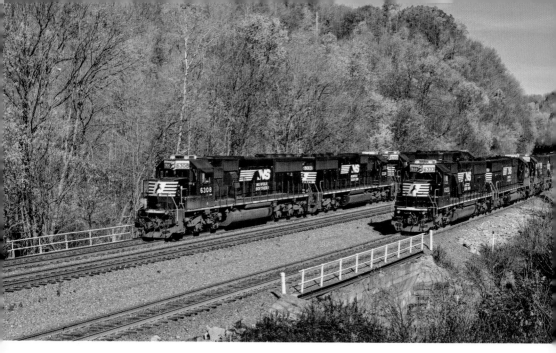

The Pittsburgh Line is one of the busiest on the NS system. At Cassandra, PA, we catch helpers meeting on the west slope – NS EMD SD40E No. 6308 (ex-NS SD50 No. 6519) heads westbound as NS No. 590 heads eastbound with SD40E No. 6333 (ex-NS/CR SD50 Nos 5407/6713). Taken on 14 October 2014.

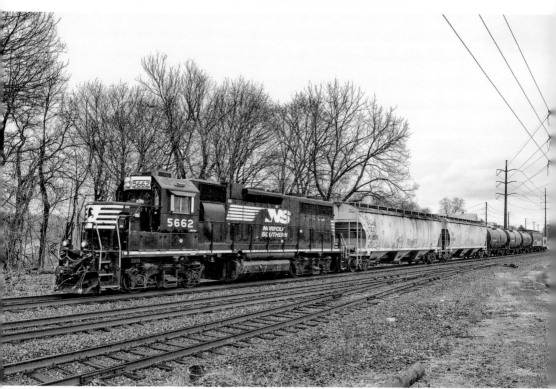

NS rebuilt EMD GP38-2 No. 5662 (ex-NS GP38 No. 2907, ex-CR/PC No. 7726) is seen heading through Hummelstown, PA with No. H24, the 'Hershey Shifter'. Taken on 16 February 2018.

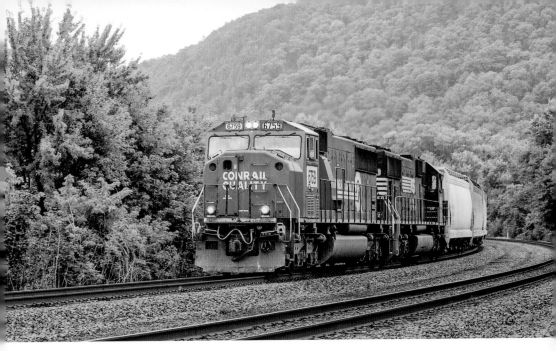

Norfolk Southern EMD SD60I No. 6759 still wears the paint of predecessor road Conrail as it heads westbound through Duncannon, PA with Conway, PA-bound manifest No. 13G on a hazy September afternoon. Taken on 9 September 2009.

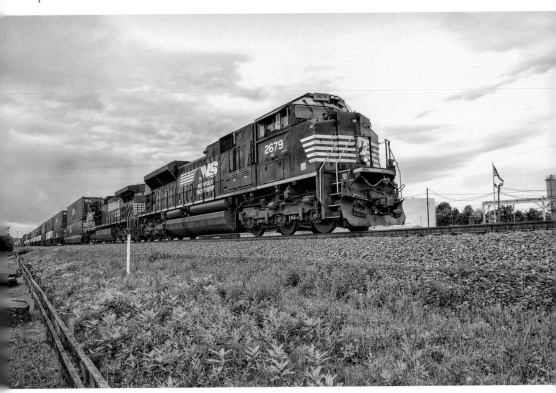

Leading eastbound No. 20T, Norfolk Southern EMD SD70M-2 No. 2679 is about to knock down the signals at CP MO in Cresson, PA when seen on 8 July 2017.

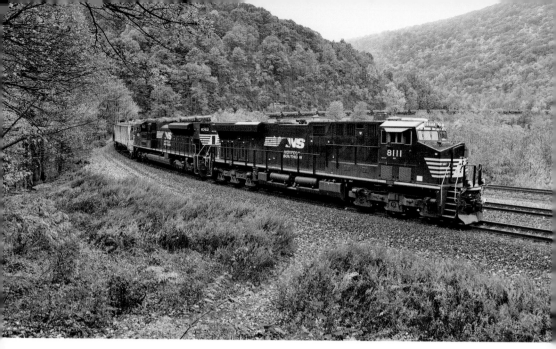

Often described as 'the eighth wonder of the world', Horseshoe Curve in Altoona, PA is a must-see for any railfan. GE-built ES44AC No. 8111 leads westbound No. 67Z around the curve as Fall colors begin to show. Taken on 16 October 2015.

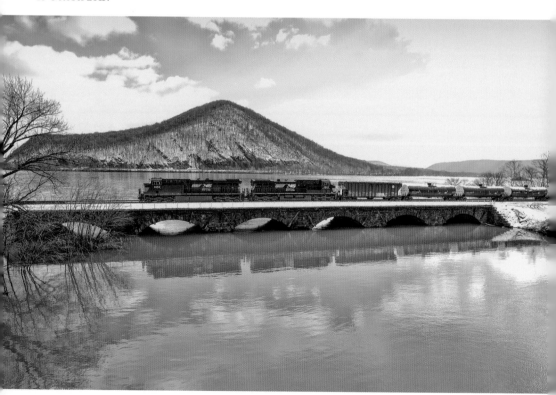

A GE ES44AC and AC44C6M cross a very high Sherman's Creek in Duncannon, PA with Chicago bound ethanol train No. 67X. Taken on 18 February 2018.

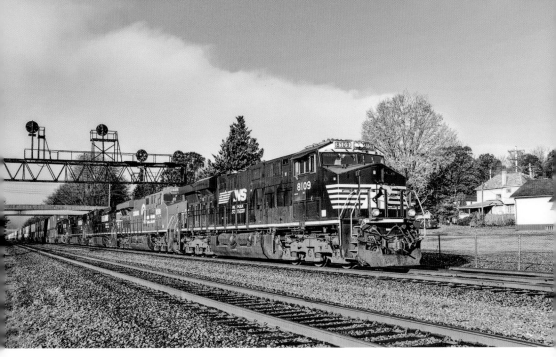

NS No. 26T rolls through Summerhill, PA with GE ES44AC No. 8109 on the point and the Conrail heritage unit trailing second out. Taken on 19 October 2015.

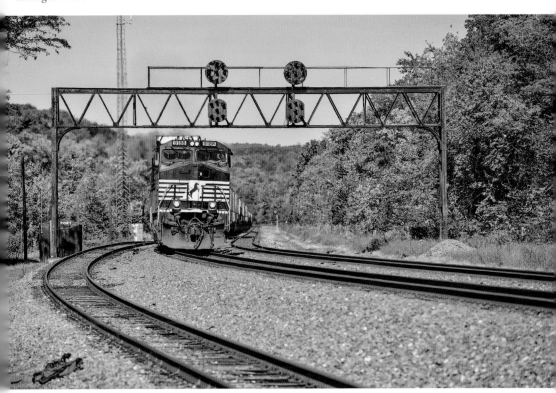

NS GE Dash-9 No. 9188 leads New Jersey-bound No. 20W under the PRR signals at milepost 135 on the Pittsburgh Line in Newport, PA. Taken on 11 October 2015.

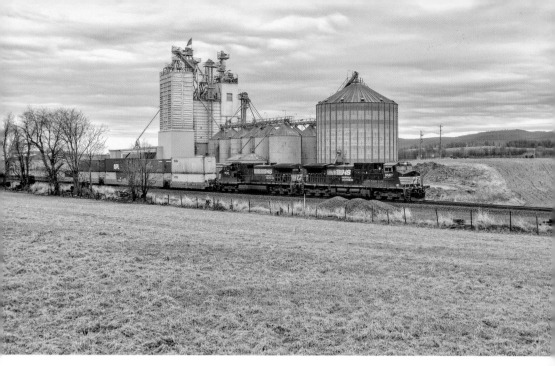

Two of Norfolk Southern's omnipresent GE Dash-9s bring Norfolk, VA-bound intermodal No. 228 through Shippensburg, PA on the Lurgan Branch. Taken on 16 February 2018.

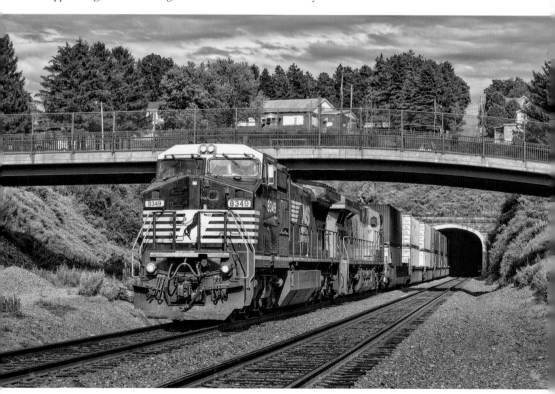

Back on home rails, NS GE Dash-8 No. 8349 (ex-CR No. 6109) leads Chicago bound No. 23M out of the Allegheny Tunnel at Gallitzin, PA on the Pittsburgh Line. Taken on 8 July 2017.

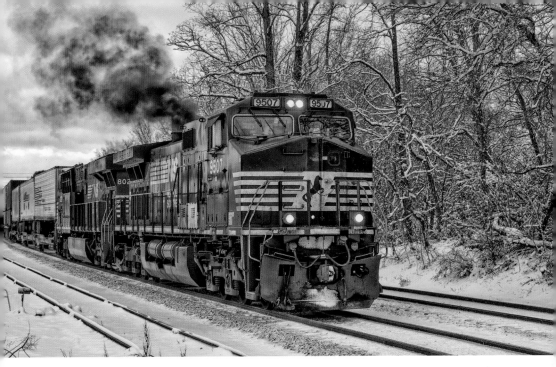

As the GE Dash-9 leader does its best steam engine impression, eastbound No. 20E heads through Hummelstown, PA on a frosty winter morning. Taken on 18 February 2018.

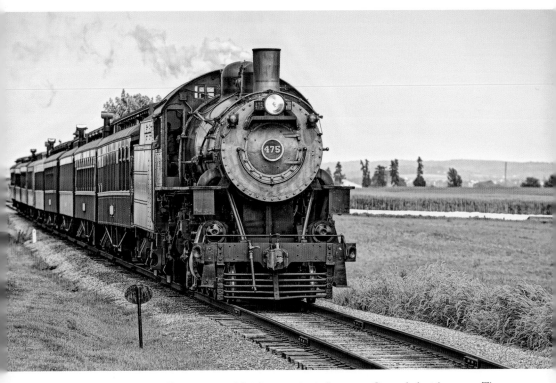

The Strasburg Railroad runs a small passenger and freight operation in Lancaster County's Amish country. They are renowned for their well cared-for small to medium-size steam power. In this shot, we see ex-N&W M Class 4-8-0 No. 475 leading the afternoon train back towards Strasburg. Taken on 26 July 2015.

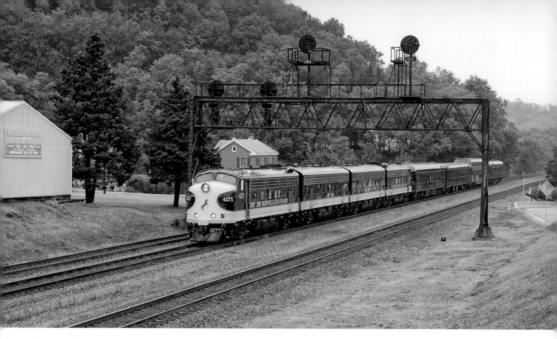

Norfolk Southern keeps a classic set of EMD F units and passenger cars for use on their business train. The OCS is seen ducking under the classic PRR era signal bridge at milepost 263 in Sumerhill, PA as it heads westbound on the Pittsburgh Line. The scheme used on the F units is a tribute to the Southern Railway, while the passenger cars evoke a Norfolk & Western heritage. Taken on 6 August 2010.

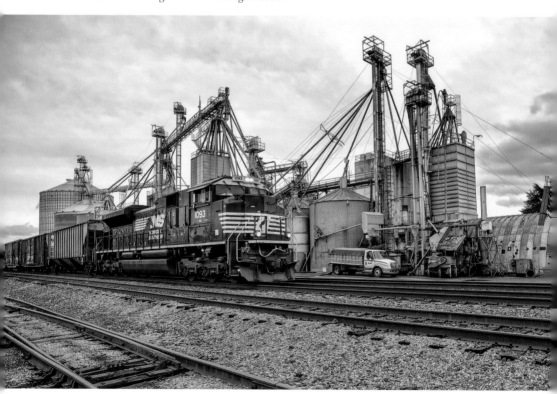

A single EMD SD70ACe is up to the task of powering westbound extra No. M9G as it passes Triple M Farms in Avon, PA on the Harrisburg Line. Taken on 18 February 2018.

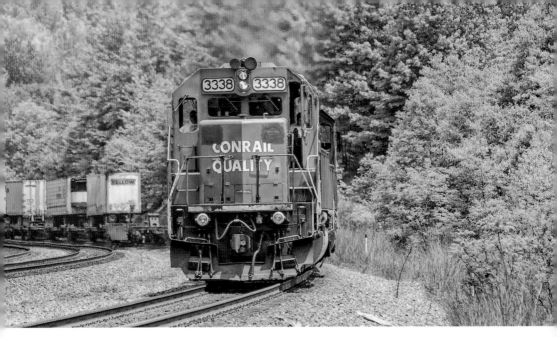

After the takeover of Conrail, Norfolk Southern continued the practice of using EMD SD40-2s in helper service on the east and west slopes of the Pittsburgh Line between Altoona and Johnstown. The SD40-2s were eventually replaced by the rebuilt SD40E model. Former Conrail SD40-2 No. 6638 is seen at Cassandra, PA as it assists an eastbound stack train heading to Altoona. Taken on 26 May 2007.

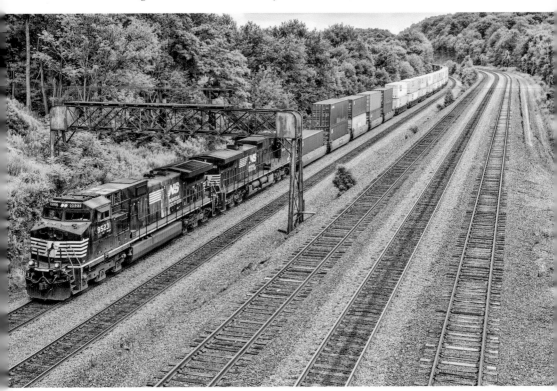

The view from PA Route 53 shows us Norfolk Southern Dash-9 No. 9523 leading No. 21V under the PRR signals in Cresson, PA. Taken on 7 July 2017.

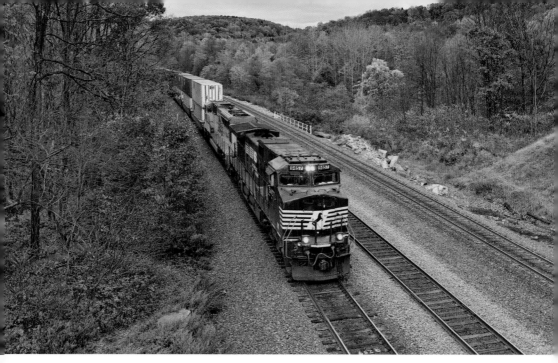

NS GE Dash-9 No. 9457 leads No. 23M westbound through colorful Cassandra, PA on the west slope of the Pittsburgh Line. Taken on 17 October 2015.

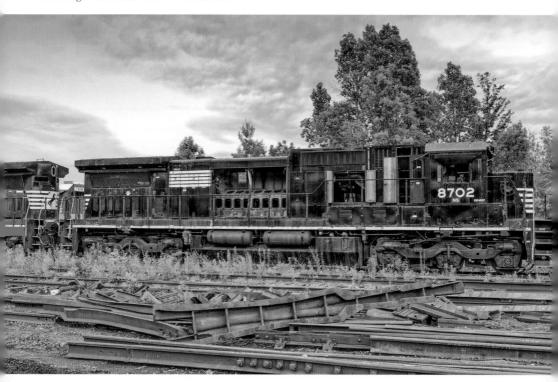

While there is a strong second-hand market for EMD locomotives, the same cannot be said for GE diesels. 1990-built No. 8-40C sits stripped of most of its reusable parts in Cresson Steel as it awaits scrapping. Taken on 7 October 2017.

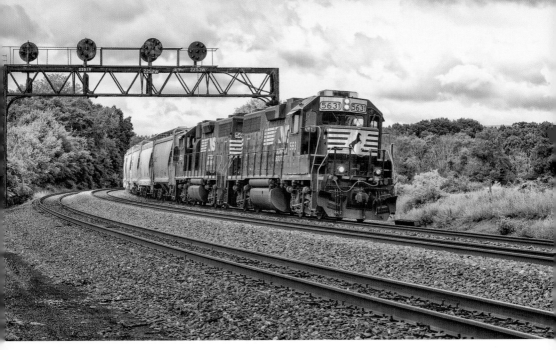

NS C42 ducks under the soon to be replaced Pennsy signals at milepost 225 in Tipton, PA on the Pittsburgh Line with a pair of rebuilt EMD GP38-2s for power. Ex-CR/PC No. 7714 is leading. Taken on 7 July 2017.

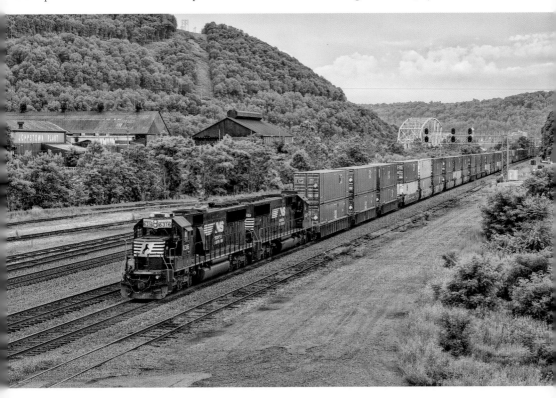

A pair of EMD SD40E helpers (snappers in PRR parlance) lend a hand to westbound No. 23M as it passes through East Conemaugh, PA. SD40E No. 6316 was rebuilt from Conrail EMD SD50 No. 6761. Taken on 8 July 2017.

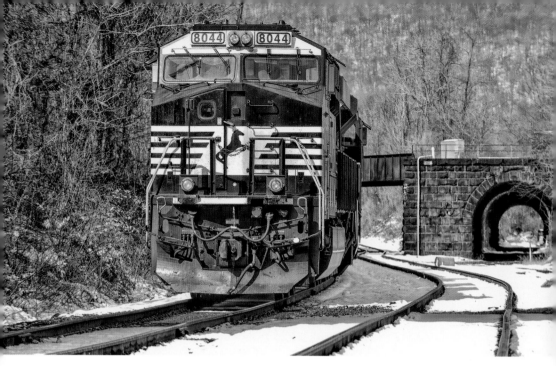

Norfolk Southern GE ES44AC No. 8044 is seen leading coal train No. 592 into Enola Yard in Marysville, PA as fresh snowfall blankets the ground. Taken on 18 February 2018.

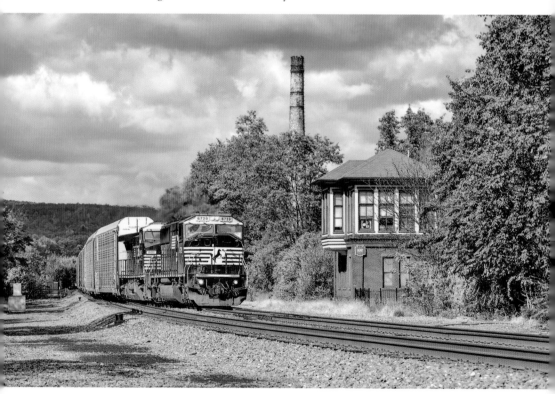

A pair of ex-Conrail motors lead eastbound No. W6A past HUNT tower on the Pittsburgh Line in Huntingdon, PA. NS EMD SD60I No. 6729 was originally built as CR No. 5596. Taken on 16 October 2015.

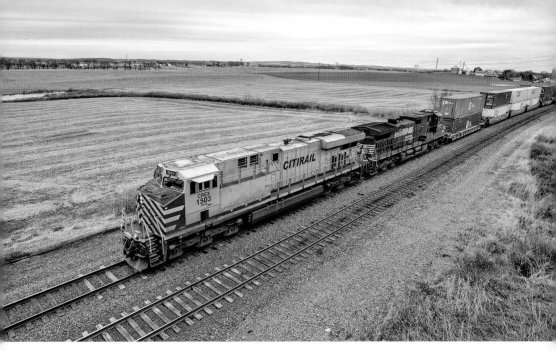

CITIRAIL operates a fleet of lease units that can show up anywhere in the country. On this occasion, CITIRAIL GE ES44AC No. 1503 is passing through Lyons, PA on the Reading Line as it leads Atlanta, GA-bound No. 211. Taken on 17 February 2018.

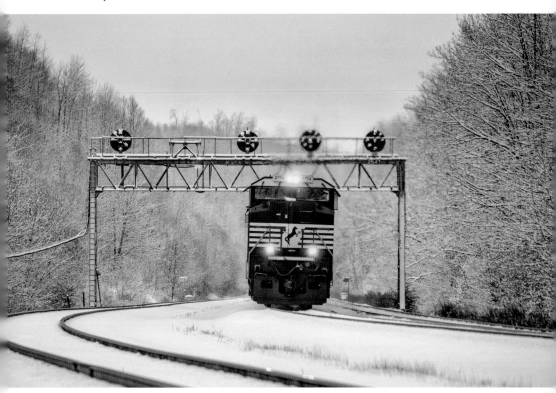

In a Christmas card setting, NS SD70M-2 No. 2774 leads Harrisburg, PA-bound No. 26T under the classic PRR signals at milepost 254 on the Pittsburgh Line in Lilly, PA. Taken on 24 January 2015.

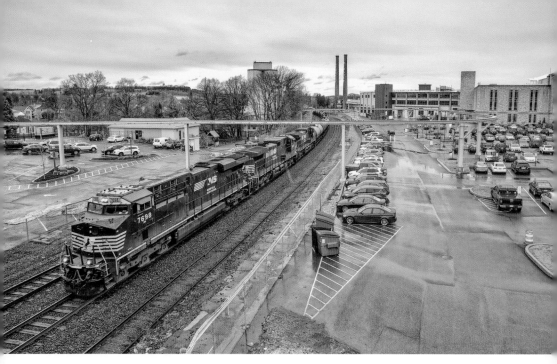

Norfolk Southern GE ES44DC No. 7698 leads Bellevue, OH-bound No. 19G through 'The Sweetest Place on Earth' – Hershey, PA. The track above the train is the Hershey Park monorail. Taken on 16 February 2018.

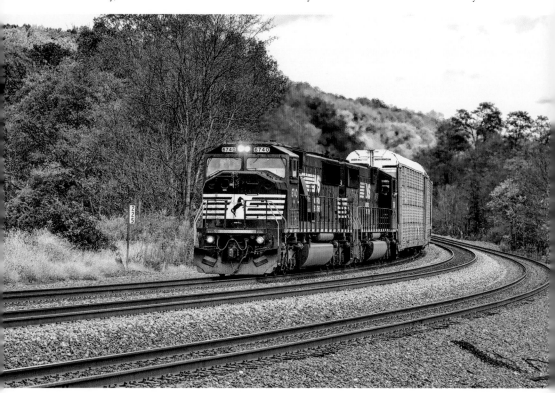

A matched pair of ex-Conrail EMD SD60Is lead westbound No. 27N through milepost 225 of the Pittsburgh Line at Tipton, PA. NS No. 6729 (ex-CR No. 5596) is on the point. Taken on 16 October 2015.

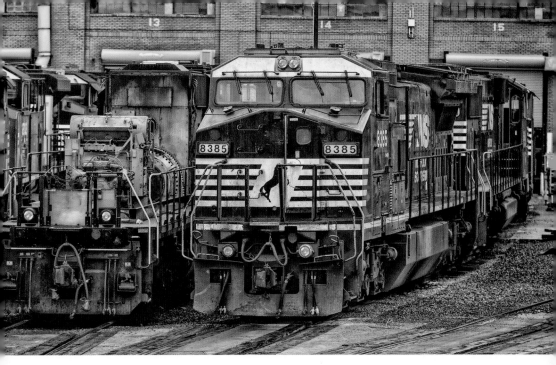

Norfolk Southern Dash 8-40CW No. 8385 (ex-CR No. 6173) sits at the Juniata shops in Altoona, PA, awaiting some work, while an unidentified EMD without the long hood sits next to it. Taken on 9 July 2017.

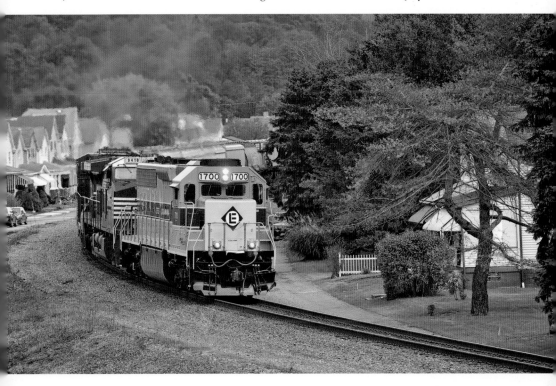

In a setting akin to a model railroad, Norfolk Sothern's Erie Lackawanna heritage-painted EMD SD45-2 heads through East Vandergrift, PA on the Conemaugh Line with No. 10N on its maiden voyage after getting repainted. Taken on 18 October 2015.

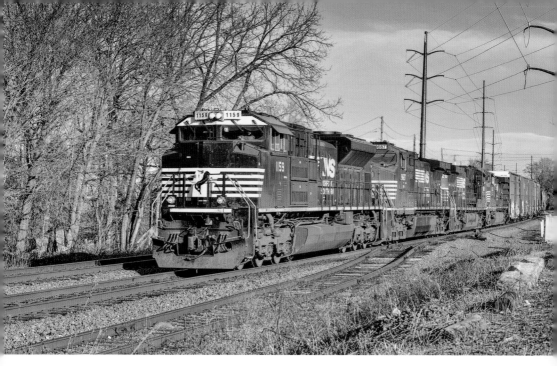

Birmingham, AL-bound No. 15T heads through Hummelstown, PA in late afternoon winter light with EMD SD70ACe No. 1159 on the point. Taken on 12 January 2017.

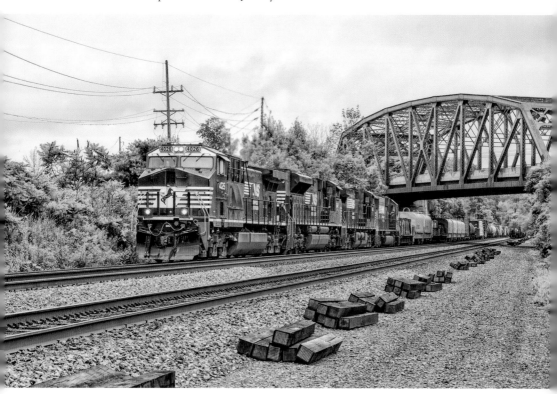

Norfolk Southern rebuilt GE AC44C6M No. 4026 (ex NS D9-40C No. 8875) leads eastbound No. 14G through Grazierville, PA on the Pittsburgh Line. Taken on 5 July 2017.

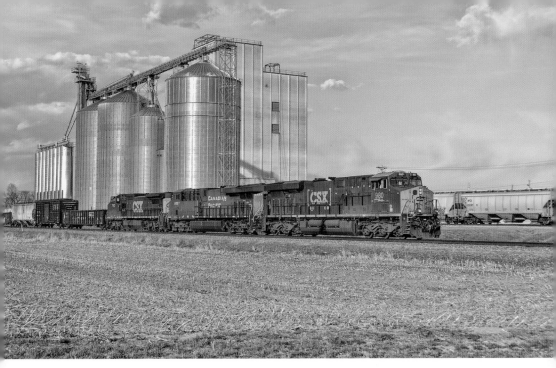

CSX GE ES44AC-H No. 7907 leads No. KH00 past the Wenger Feed Mill complex on the Lurgan Branch in Shippensburg, PA. Taken on 12 April 2018.

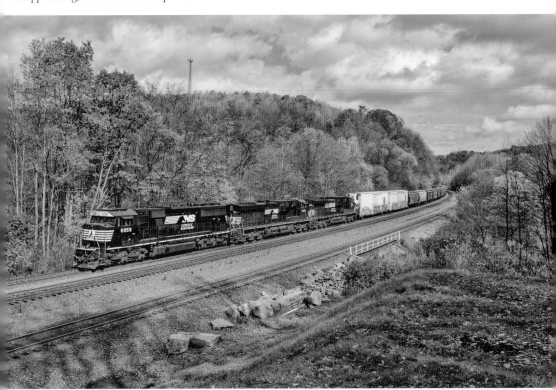

Norfolk Southern EMD SD60E No. 6959 (ex-NS SD60 No. 6601) leads westbound extra No. M1V through Cassandra, PA as Fall colors brighten the scene. Taken on 17 October 2014.

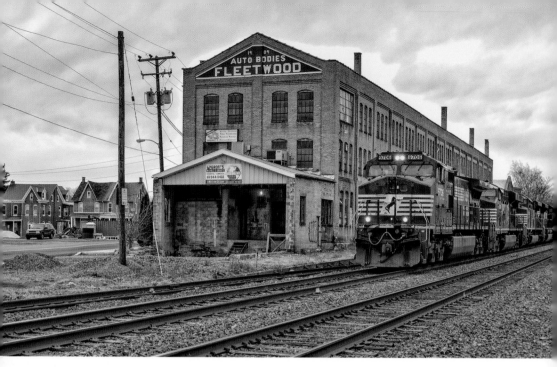

Norfolk Southern GE Dash-9 No. 9706 leads No. 65K past the old Fleetwood autobody plant in Fleetwood, PA on the Reading Line. Taken on 17 February 2018.

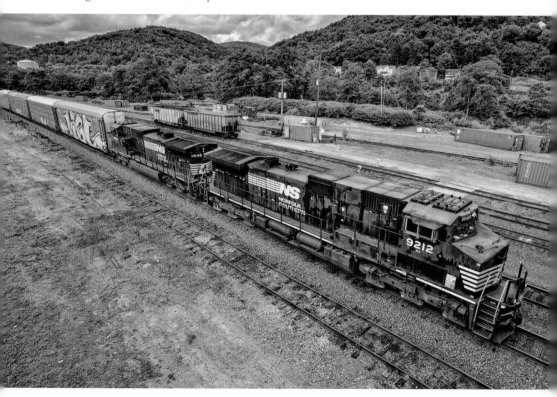

Norfolk Southern Dash-9s Nos 9212 and 9648 lead westbound No. 11J through CP-C at East Conemaugh, PA on the Pittsburgh Line. Taken on 7 July 2017.

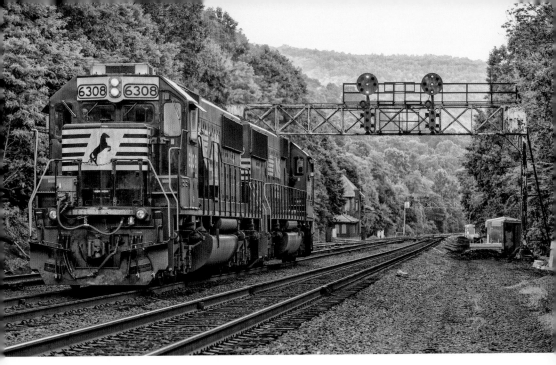

A set of Norfolk Southern EMD SD40E helpers drift downgrade past the MG tower and the doomed PRR signals as they head eastbound towards downtown Altoona. Taken on 7 October 2017.

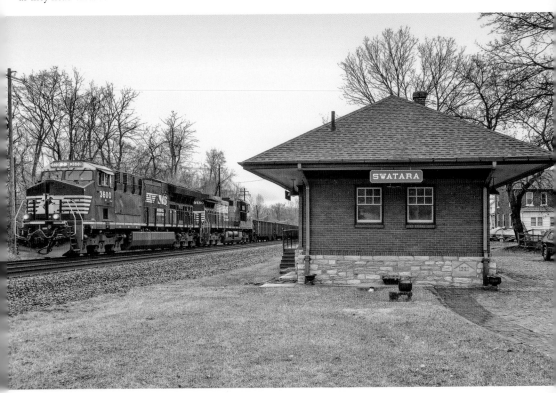

The class unit for Norfolk Southern's GE ET44AC fleet passes the former Reading station at Swatara, PA as it leads slab train No. 60N westbound on the Harrisburg Line. Taken on 16 February 2018.

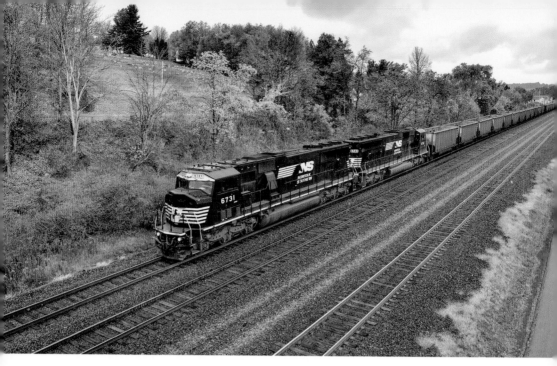

A pair of ex-Conrail EMD motors lead No. 539 westbound through Lilly, PA on the Pittsburgh Line. NS SD60I No. 6731 is former Conrail No. 5600. Taken on 18 October 2016.

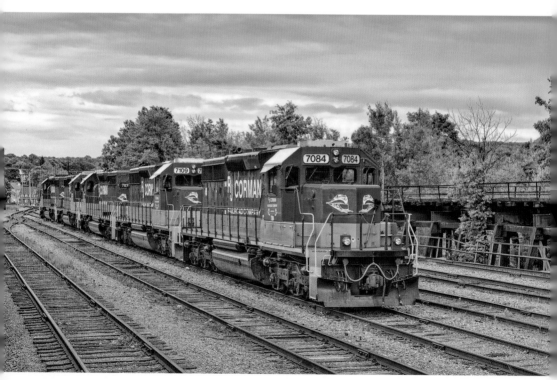

Short Line RJ Corman operates a cluster of ex-NYC and PRR coal branches in western PA. Five EMD SD40-2 units rest at the interchange with NS in Cresson, PA. RJ Corman SD40-2 No. 7084 was built in 1978 as Burlington Northern No. 7084. Taken on 7 July 2017.

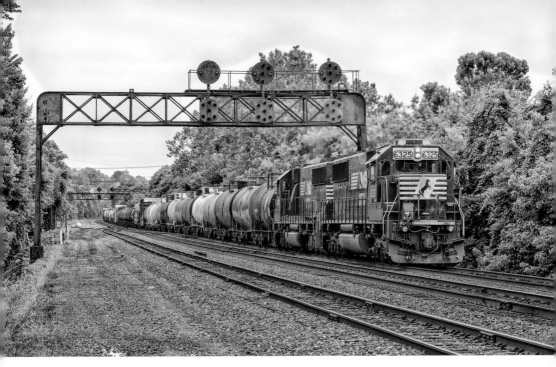

Norfolk Southern EMD SD40E No. 6325 (ex-CR SD50 No. 6715) shoves westbound No. 17G under the classic PRR signals at Latrobe, PA. Taken on 8 July 2017.

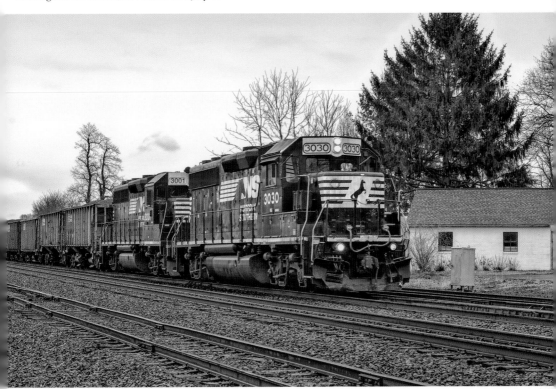

At Hershey, PA we find two former Conrail EMD GP40-2 units running 'elephant style' as they lead MoW train No. 921 towards Harrisburg. NS No. 3030 was built in 1978 as Conrail No. 3329. Taken on 16 February 2018.

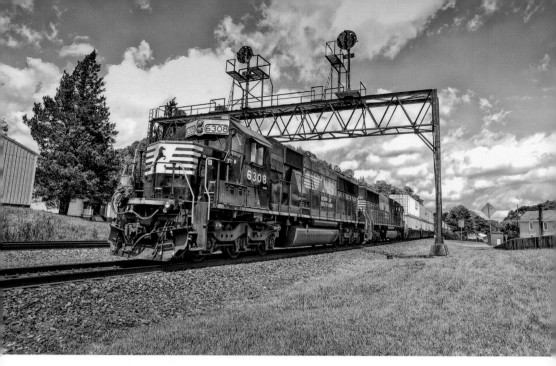

A wide-angle view of EMD SD40E No. 6308 (ex-NS EMD SD60 No. 6519) as it shoves No. 20Q eastbound under the iconic PRR signal bridge in Summerhill, PA. Taken on 7 July 2017.

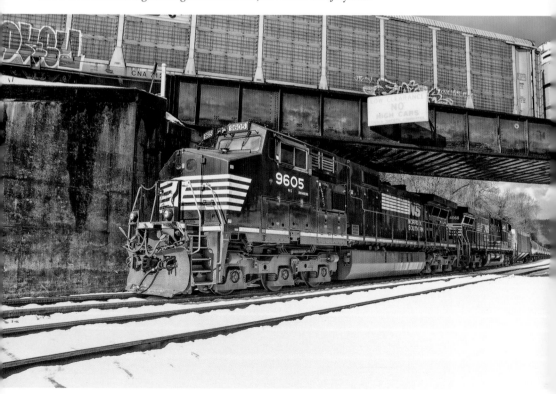

At Marysville, PA we find Norfolk Southern GE Dash 9 No. 9605 leading No. 68R into Enola Yard while No. 18N heads out overhead and prepares to cross the Rockville Bridge into Harrisburg. Taken on 18 February 2018.

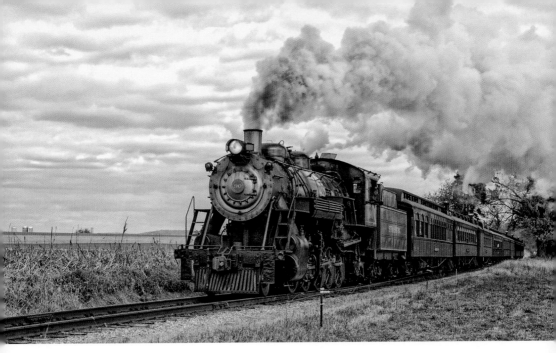

Originally built by Baldwin Locomotive Works in 1924 for the Great Western Railway, Strasburg Railway 2-10-0 No. 90 shows no signs of slowing down as she approaches her 100th birthday. She's seen heading through Amish country in Pennsylvania with a daily passenger train. Taken on 29 October 2005.

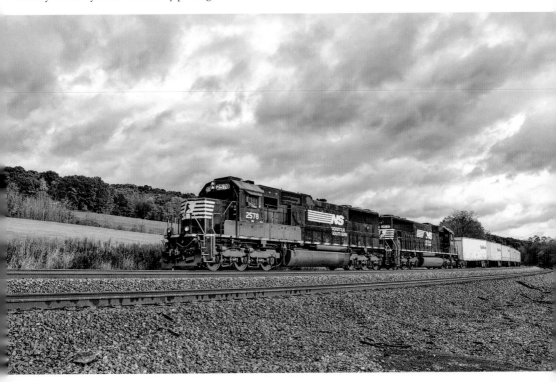

Former Conrail EMD SD70 No. 2578 was built to Norfolk Southern specs, as the order was delivered after the breakup of the railroad. The unit heads through Tipton, PA with a now discontinued Roadrailer train as storm clouds roll in overhead. Taken on 17 October 2015.

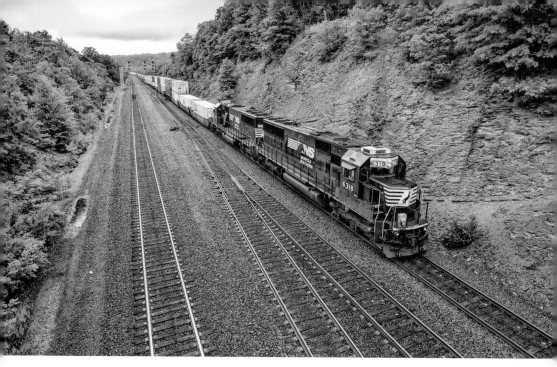

Norfolk Southern EMD SD40E No. 6318 (ex-CR SD50 No. 6707) shoves No. 21A westbound past CP-SLOPE in Altoona as it begins to tackle the steep grade that lies ahead. Taken on 7 July 2017.

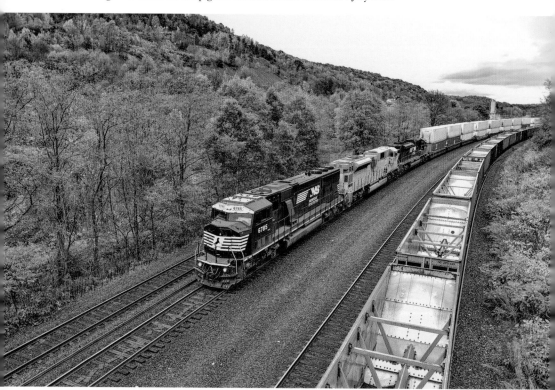

Former Conrail EMD SD60M No. 5538 is on the point of No. 21E as it heads through South Fork, PA on the Pittsburgh Line. Taken on 17 October 2016.

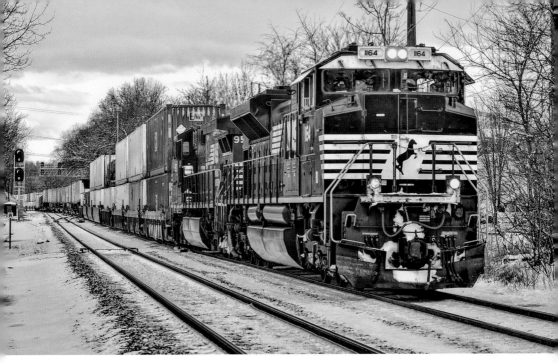

Norfolk Southern EMD SD70ACe No. 1164 crawls through CP-BURKE in Hummelstown, PA with Morrisville, PA-bound No. 24K on a chilly winter morning. Taken on 18 February 2018.

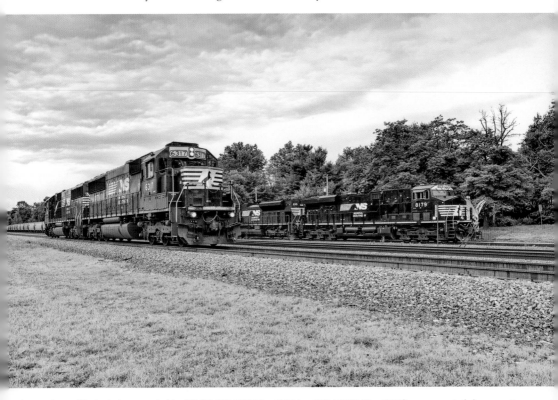

An eastbound light helper set, led by EMD SD40E No. 6317 (ex-CR SD50 No. 6769), passes a tied down grain train with a GE ES44AC on the head end in Cresson, PA. Taken on 9 July 2017.

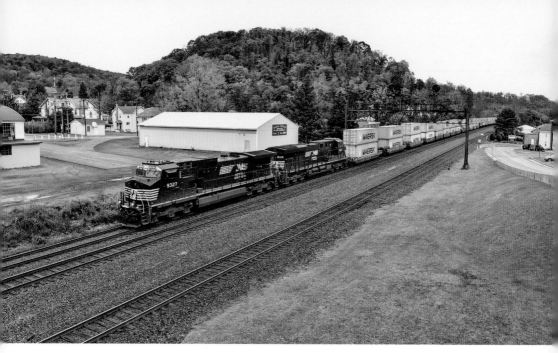

Norfolk Southern GE Dash-9 No. 9327 leads No. 23Z under the PRR signals at milepost 263 on the Pittsburgh Line in Summerhill, PA. Taken on 18 October 2016.

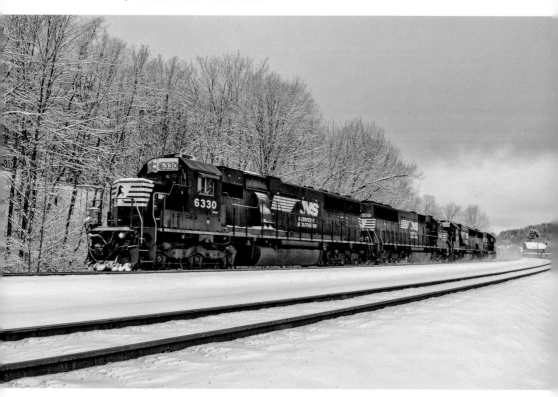

With fresh snow blanketing the rails, a four pack of EMD SD40E helpers kick up white powder as they run light through Lilly, PA. Taken on 25 January 2015.

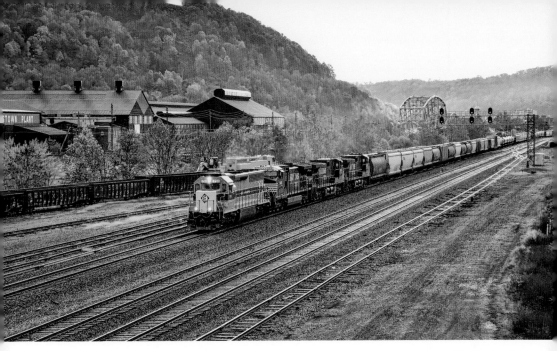

As the sun begins to dip behind the mountains, No. 10N comes into East Conemaugh, PA with Norfolk Southern's Erie Lackawanna Heritage EMD SD45-2 leading as it continues the maiden journey east after being repainted. Taken on 18 October 2015.

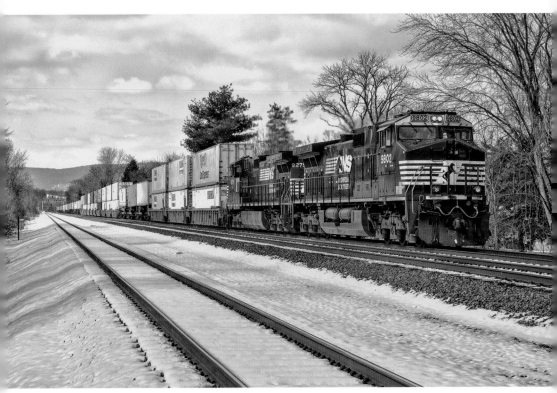

Norfolk Southern GE Dash-9 40CW No. 9802 leads No. 20K through Cove, PA on the eastern end of the Pittsburgh Line. Taken on 18 February 2018.

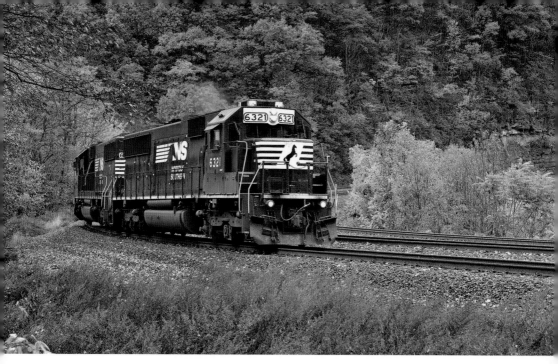

A pair of former Conrail EMD SD50s, now rebuilt as SD40E units, head light around Horseshoe Curve among some nice Fall colors. NS No. 6321 is ex-CR SD50 No. 6708. Taken on 17 October 2016.

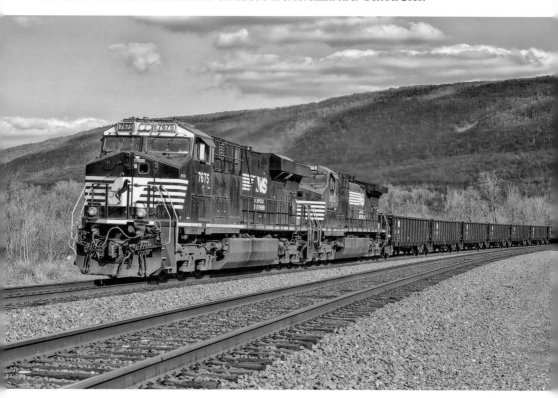

NS GE ES44DC No. 7675 and GE Dash 9 No. 9113, running 'elephant style', are seen leading Camden, NJ–River Rouge, MI slab train No. 60N at Mexico, PA on the Pittsburgh Line. Taken on 4 April 2018.